CONTENTS

I t's nearly fifteen years since Paper Tiger published *Lightship*, my last collection of science fiction paintings. I'm still painting the stuff – though these days with the help of optical enhancement devices (my 'specs' – as the ravages of time take their inevitable toll) and with the hindrance of what I call 'airbrush thumb'. (Nobody told me that airbrushing could become physically painful!). And fifteen years ago I hadn't the tiniest notion that by the turn of the millennium I would, in some part, be abandoning the traditional tools – (I count the airbrush as such, though once it was that 'newfangled gadget') – and creating my pictures on a sort of television screen with the help of a thing called a 'digitizing tablet' and an electronic, pressure-sensitive pen. Never mind science fiction. Science fact can be pretty cool too! There's only one digitally realized image in this collection – and that's just a detail from a much larger picture. A sort of taster for the next collection! Creating science fiction art has become as much a part of my life as eating or breathing. I don't see retirement as an option. I'm still going to be inflicting my pictorial musings and ravings on you forty years from now! I simply can't imagine doing anything else.

Jim Burns 1999

T he following five paintings are all that exist of *Navigators of the Empyrean* – the working title for a book I started to write and illustrate, courtesy of Games Workshop, back in the late 1980s. Unfortunately it was never completed. It was an attempt to convey in pictures and words the entire future history of man, right up to his final extinction. Intended as a sort of Stapledonian epic, I think it was proof indeed that I've read too much science fiction!

Below:
THE TERRAN DERELICT

Towards the end of *Navigators of the Empyrean* I commenced the business of wiping out my cosmos-striding Overlords – namely Humanity – whose turn to taste the bitter pill of hubris after a billion years of galactic empire-building had arrived. Humans had peered in awe at the strange pilot of the Miranda Object. Now we have this peculiar little bug-eyed being similarly overwhelmed at its discovery of the *Terran Derelict*! It might be supposed that the book exists in some sort of entirety given we've arrived at this late point in the unfolding narrative. The truth is - this was the first painting I completed!

Opposite page:
MUSCLE SHIP OF THE LALANDIAN HEGEMONY

My intention was to 'evolve' in paint an artefact which, through my detached form of involvement with its creation, might convince as the product of different thought processes. A truly alien object. The result had a sense of mass about it, made more striking by placing it in conjunction with a surface of some kind – hence the pink, watery backdrop and the reflection of the object in the lake below.

Thus was created, more by accident than design – '*Muscle Ship of the Lalandian Hegemony Precision De-warping over Blood Lake, Faraway, Deneb System*'.

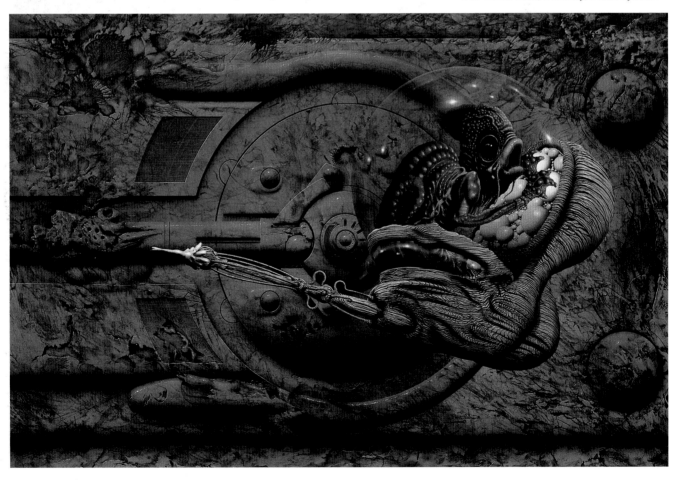

TRANSLUMINAL

THE PAINTINGS OF JIM BURNS

There is no excellent beauty that hath not some strangeness in the proportion
Francis Bacon (From Essays 'Of Beauty' 1625)

Paper Tiger

This book is dedicated to the writers of science fiction

'The changing of bodies into light, and light into bodies, is very conformable to the course of nature, which seems delighted with transmutations.'

Sir Isaac Newton, from *Opticks*, 1730

From the beginning, the putting together of this collection has been a remarkably smooth, hassle-free and pleasant experience. I should like to thank some of the people who made it so: Muna Reyal at Paper Tiger, who with such charm and lightness of touch kept everyone in line and on time, Paul Barnett for his unflagging enthusiasm, dogged persistence and many useful suggestions, John Jarrold for being a good friend (and for not laughing too loudly as I wandered off my own turf) and Malcolm Couch for his forbearance and his enthusiasm, but mostly for his great skill – a pig's ear can be a silk purse! In a wider context, Jane and Howard Frank for their friendship and encouragement and great, great patience with a 'flaky artist'! John B. Spencer, musician and writer and who, way, way back, hauled me aboard the good ship Opportunity. And of course, my agents Alan Lynch and Val Paine, who endure so much with good humour, but most of all, Alison Eldred, agent and friend for a quarter of a century, and without whose energy and determination *Transluminal* would still be just a vague, formless half-wish in the back of my mind. And, as always, my family. They are the bedrock.

First published in Great Britain in 1999
by Paper Tiger
An imprint of Collins & Brown
London House, Great Eastern Wharf, Parkgate Road
London SW11 4NQ
www.papertiger.co.uk

9 8 7 6 5 4 3 2

British Library Cataloguing-in-Publication Data:
A catalogue record for this book is available from the British Library.

ISBN 1 85585 678 6

Commissioning editor: Paul Barnett
Consultant editor: John Jarrold
Designer: Malcolm Couch

Reproduction by Global Colour, Malaysia
Printed and bound in Singapore by Craft Pte Ltd

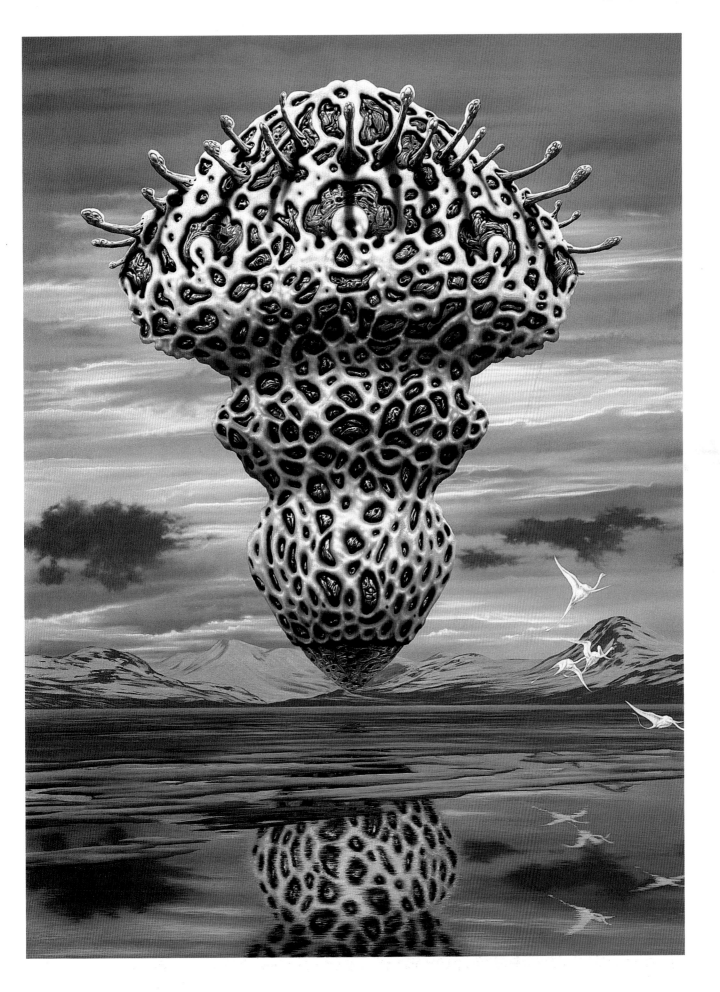

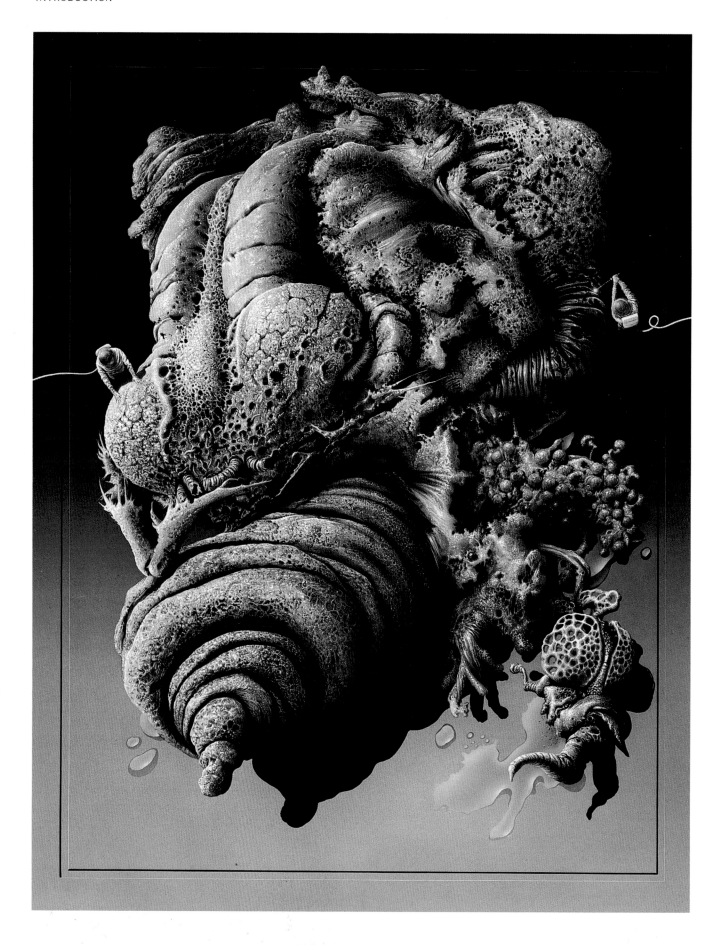

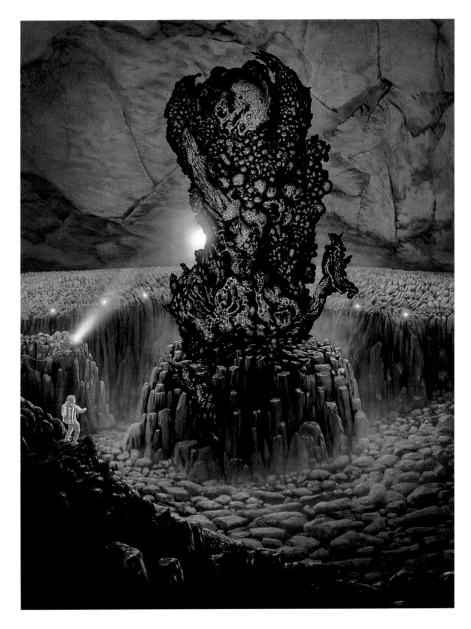

Left:
THE MIRANDA OBJECT

Painstaking examination of high-resolution images sent back by Voyager 2 from its encounter with Uranus and its moons in January 1986 revealed an 'anomaly' at the base of a 5km high cliff face on the tortured surface of the moon, Miranda. A couple of decades later the more sophisticated information-gathering capabilities of the Sagan mission confirmed what had been suspected by some – that the anomaly, which was henceforward referred to as 'The Miranda Object', was in fact an artefact of extra-terrestrial origin. It wasn't until the manned landing of 2066 – eighty years after the original Voyager shots had been received back on Earth – that men finally came face to face with the indisputable fact that they were not alone in the Universe. The painting is supposed to depict the alien vessel in its apparently 'upright' disposition found after some early excavation work around the site. A character from the 'plot' can be seen in a spacesuit to the left. Don't ask me what his name was – I've long forgotten!

Below:
GRAIL IMAGING

OK – So the years drift by and, at almost ruinous expense, large hunks of the Miranda Object are lugged back into Earth orbit. In my original text I went into all sorts of corny gee-whiz solutions to the mechanics of getting the alien wreck down to the surface of the Earth – including the de-mothballing of the old Soviet Buran shuttle!

The acronym 'GRAIL' stands for 'Geo-racinate Artificial Intelligence Link', which I thought sounded rather cool at the time – it represents one of those ubiquitous mega-computers so often encountered in SF. The painting shows GRAIL's stab at the supposed appearance of the Object – 'to within a percentile point or two of accuracy'. An astronaut is dropped in to give a sense of scale and the background is an accurately painted rendering of the actual Voyager shot of Miranda which 'inspired' the idea.

Opposite page:
DISSECTION OF THE MIRANDA PILOT

Of course, what 'the powers that be' had hoped to extract from the heap of extraterrestrial slag was the secret of – yes, you guessed it! – its *stardrive*! What they actually found was an almost impenetrable jungle of complex chitinous forms and shapes, and fused into this suspiciously insectile mess is the vacuum-mummified remains of its sole occupant. The Miranda 'pilot' is based as much as anything upon the bizarre pets my second daughter, Megan, was frightening all her friends with at the time, mostly various species of large, tropical stick insects – for the entomologists among you: the Giant Spiny, the Giant Prickly and – best and scariest of all –the Jungle Nymph. One does not have to venture into the cosmos to come face to face with the truly alien!

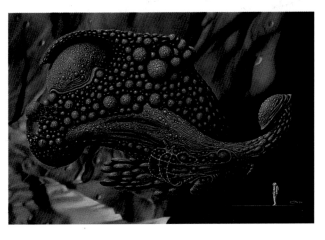

DAVID BRIN

What do I like about the illustrations Jim Burns created for my books?

Beyond his wonderful use of colour and perspective . . . and the incredibly realistic portrayals of both human and alien characters . . . there is something even more important – a sense of immediacy and *expectation*.

Take the painting he did for *The River of Time*. Do you see any explosions? Any planetary collisions or laser beams shattering fleets of star cruisers? No. Instead we have a strangely shimmering sky above a pastoral wilderness, into which a woman has just stepped – emerging from a modest space capsule. Her demeanour is calm, her expression placid. And yet, the scene is filled with tension! The breath catches in our throats as we feel a sensation that her words – when she finally does speak – will be of vital importance.

Of course those words will only be 'heard' if the reader buys the book, and turns to the story inside! Thus is born a synergy between story and illustration, one that not only heightens the reader's pleasure, but helps make the book a success.

Above all, however, there is a sense that this gifted artist cares about the story, just as much as the author did. The images that we see here flowed not only from his gifted imagination, but also from the words of the tale. When this happens, writer and illustrator become a team, even if their efforts were separated by months and oceans. Whenever I get a Burns illustration, I feel that the story has thenceforth become partly his, forever after.

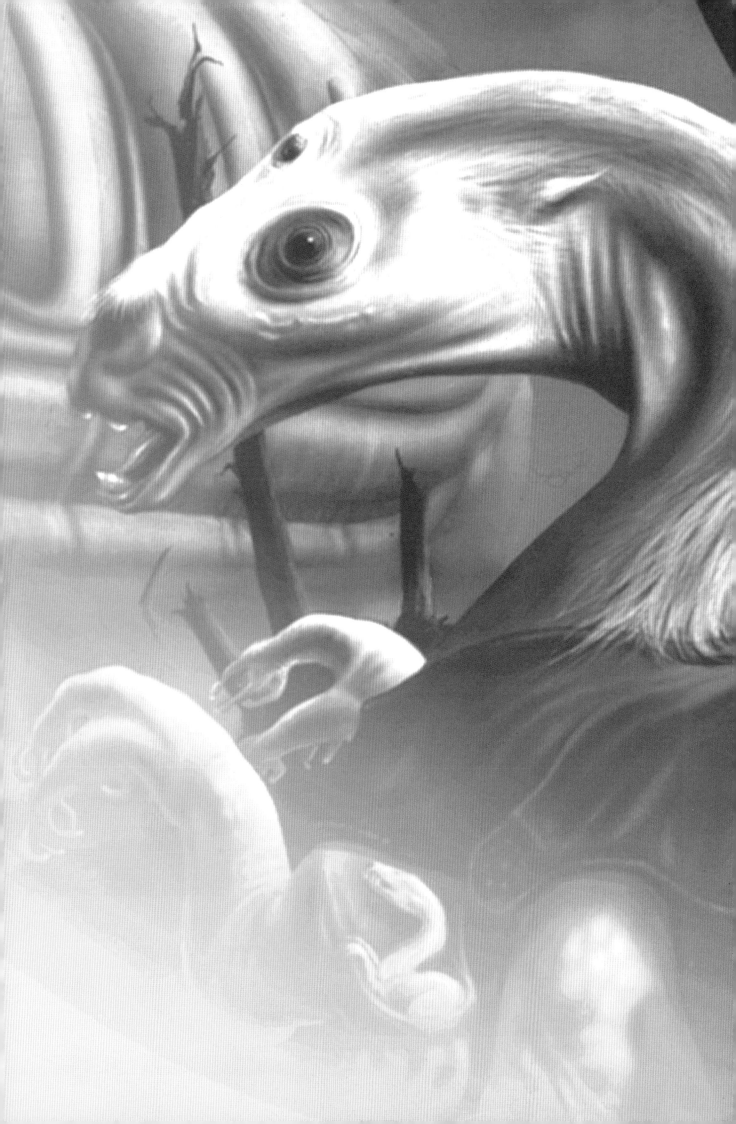

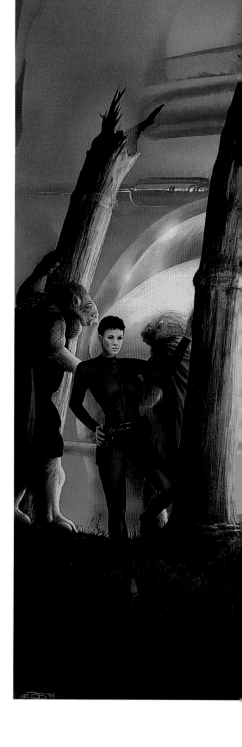

Right:
INFINITY'S SHORE
(*Bantam*)

The wonderful troupe of characters, human and alien, who parade through David Brin's Uplift books are a gift for a science fiction artist. It's been my unalloyed pleasure to paint the covers for a number of his books including two of the most recent Uplift trilogy, *Infinity's Shore* and *Heaven's Reach*. Here we have beings you care about, whether they be the amiable, rather plodding Hoons, the hyperactive, centaur-like Urs or even the totally alien g'Kek, part octopus, part wheelchair.

In this, the middle book in the second Uplift trilogy, *Infinity's Shore*, I was particularly drawn to the Urrish character, Ur-ronn. I wanted to convey the sense of twitchy, horse-like energies coupled with human-equivalent sentience. Great fun too was the little Urrish 'husband', secreted within the bluish brood-pouch suspended from his mate's body!

Below:
THE RIVER OF TIME
(*Bantam*)

David Brin seemed quite smitten with my depiction of the character Alice from the Hugo-Award-winning novella, 'The Crystal Spheres', in the collection *The River of Time*. She hangs to this day on his study wall. An attractive woman but also a rather self-confident, even challenging creature. I imagine her gazing down on David, seeming to say, 'Come on Mr Brin – stop playing Tomb Raider right now and get back to your writing.' The little egg-shaped capsule was fun to do but this painting is over twelve years old now and there are some things I would do differently if I were to start it over. In my obsession with detail, I used to get very sidetracked with, for instance, elements such as the interior of the egg-craft. I couldn't see the flatness that resulted. Painting it anew I would lose part of the interior in shadow right from the beginning, giving the craft more form and volume. The interior detailing would be suggested by a few lights and dimly suggested console edges. Greater conviction would result. A classic example of less is more! And those hard horizon edges. The mid-1980s, when latex masking fluid ruled my life!

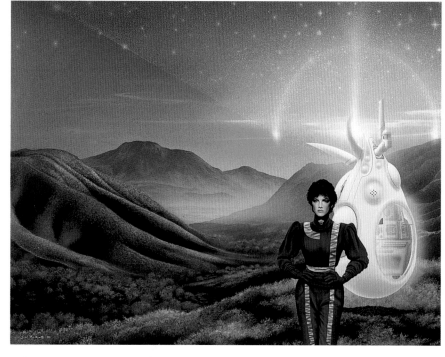

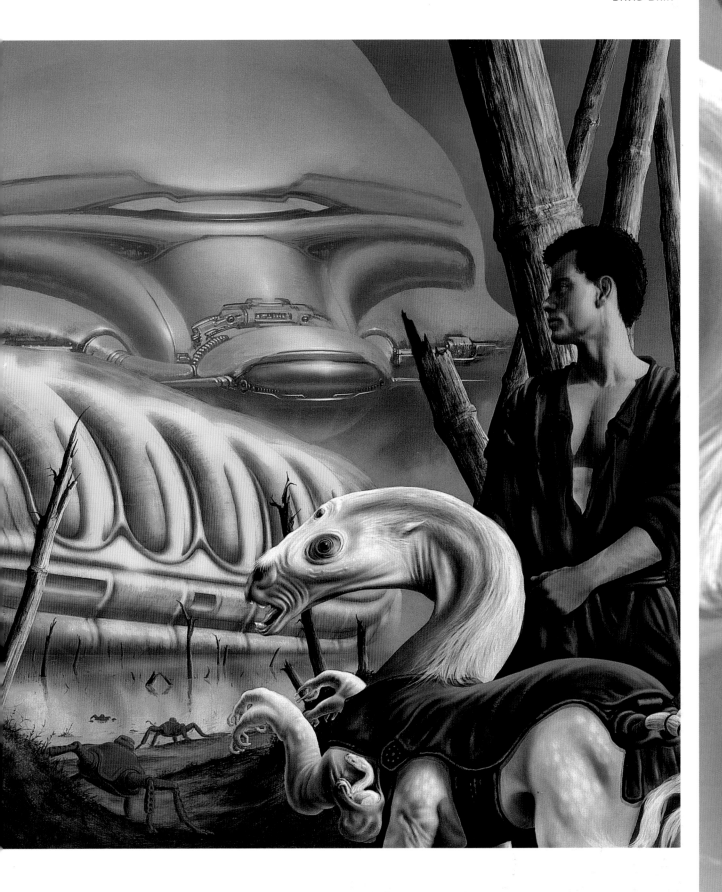

HEAVEN'S REACH
(Bantam)

The third book in the second Uplift trilogy. Some of the same merry band of strange fellow travellers as before – though my depiction of a Hoon has evolved a little from the previous effort! Once again an Urs trots across centre-stage, this time engaging in what must be a pretty bizarre dialogue with one of the uplifted Dolphin crew of the venerable *Streaker* – the Snark-class survey ship which has played such an important role in all of the Uplift books. The various sentients are functioning within and surrounded by a multiplicity of exotic constructs courtesy of a variety of intelligences – the flight deck of *Streaker* itself, the glowing NISS machine hovering before Gillian Baskin's inquiring gaze, the organic, pulsating ZANG ship beyond the massive vu-port/screen and the suggestion of titanic artificial structures in the red murk beyond. Humans and extraterrestrials struggling for survival in a universe dominated by vast, God-like intelligences. Great SF!

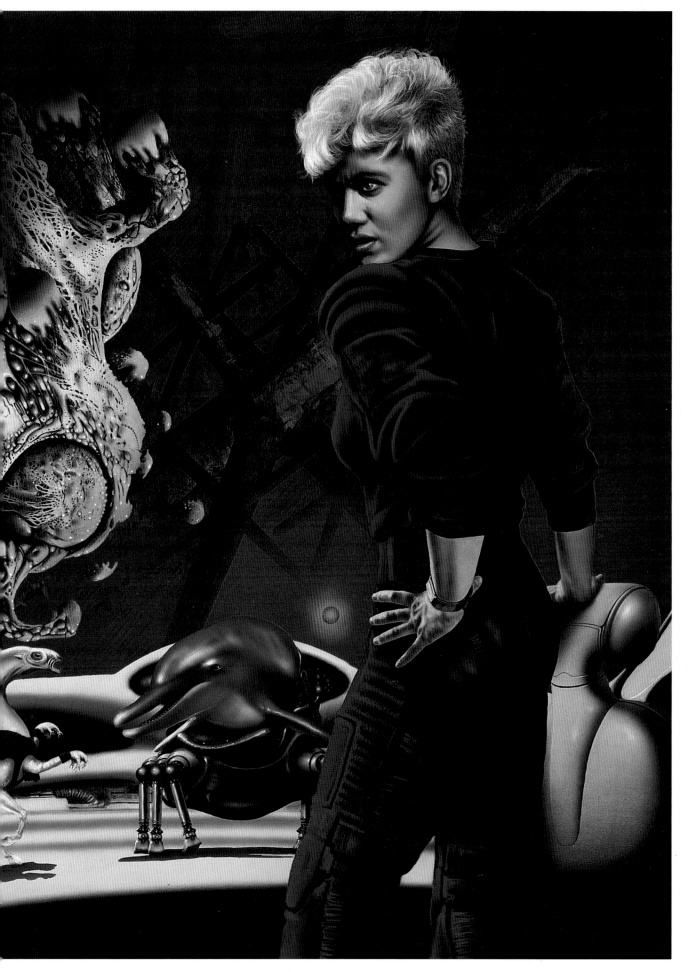

THE STAINLESS STEEL RAT'S REVENGE

Harry Harrison
(*Bantam*)

Words like 'irrepressible' and 'larger than life' spring easily to mind when the name of Harry Harrison is mentioned. We first worked together over 20 years ago on the humorous illustrated novella 'Planet Story', which in terms of advancing one's technique I still regard as the most important single job in my career. Since then I've completed the covers for a number of Harry's books, mostly in the Stainless Steel Rat series of which I think this one is my favourite as it gave me a chance to paint not only Slippery Jim di Griz – the Rat himself – but also the gorgeous, murderous Angelina, the love of Slippery Jim's life. She is the platinum blonde hanging off his arm, but I was also rather taken with the tough Amazonian warrior woman, Taze. In the end, both women ended up in the picture and I hope a little bit of the possessive rivalry for Jim's affections that exists between the two beauties has emerged in their expressions.

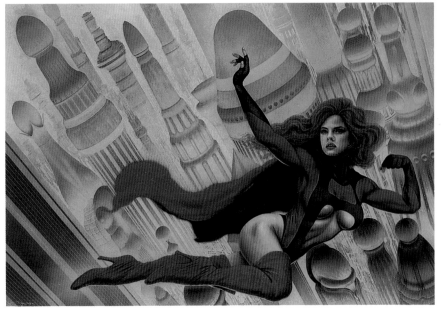

HERICANE

First issue of *Penthouse Max* magazine
(*General Media Communications Inc.*)

This was different! My first ever superheroine, the rather peculiarly named Hericane. The brief was pretty straightforward – paint a picture of our pulchritudinous heroine flying over a city. If I remember correctly, the city in my sketch accidentally carried a very slight phallic suggestion about some of its buildings. This was considered 'a very good idea', and I was asked to employ this effect with greater emphasis in the artwork. Hence those very suggestive skyscrapers. Not a favourite amongst the more politically correct, this painting. Which is too bad as I thoroughly enjoy painting the female form and – short of the totally outrageous and unforgivable – will always grab the opportunity.

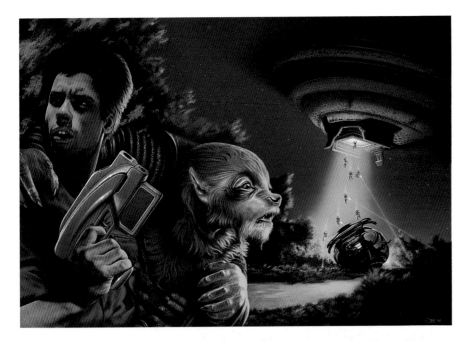

QUEST FOR TOMORROW 2 – IN ALIEN HANDS
William Shatner
(*HarperPrism*)

This was the second painting I completed in a pacy and very readable series by William Shatner – aka Captain Kirk! A name as well known as Mr Shatner's often relegates the illustration to a lesser role. It sometimes finds itself occupying a small panel of its own – which suits me very well as it usually means that one can ignore totally the design constraints of titles, author names, etc., and use the space allotted as a pure, unadulterated canvas. The various elements may be distributed around in a way that has less to do with the usual parameters of book-jacket design and more to do with one's aesthetic sensibilities.

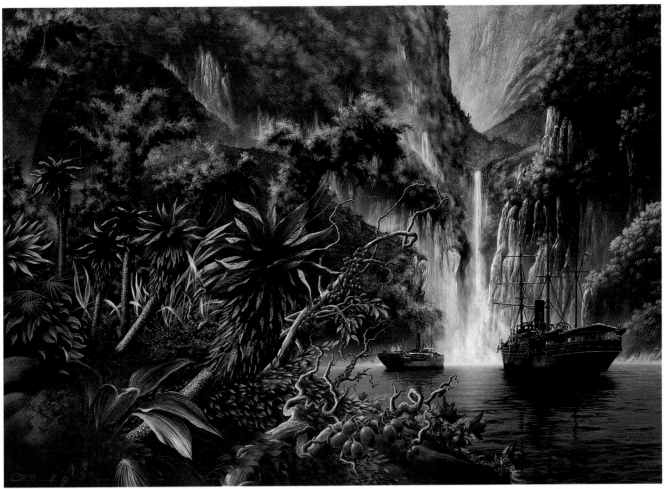

DARWINIA
Robert Charles Wilson
(*Tor*)

The strange and beguiling story of a much altered 20th century! In 1912, owing to a baffling space-time displacement event known as 'The Miracle', the old Europe of our timeline is physically replaced by a completely new geographical entity –
'Darwinia'. A land both primitive and alien it provides a weird backdrop for the unfolding of a great tale of exploration.

This painting goes down rather well with visitors to my house and at conventions. At first glance it probably passes muster as a straightforward landscape with maritime overtones – so passes the 'would it look OK over the fireplace' test!

I enjoy painting 'ships and the sea'. I particularly like the work of the maritime artist, Carl G. Evers. But to come anywhere near his perfect representations of the sea in all its moods (a pretty impossible task anyway) I would have to embrace new skills – namely mastering the traditional techniques of that most beautiful and delicate of all paint media – watercolour.

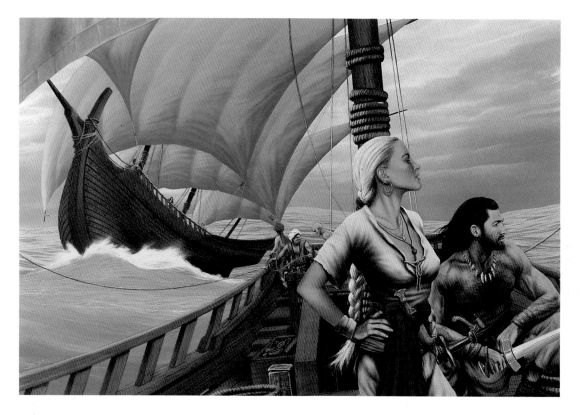

SWORD-BORN
Jennifer Roberson
(*Daw*)

This is the kind of pure fantasy material I rarely get to work with. I don't mind the particular pigeonhole I seem to have ended up in, as I'd quite happily go on producing mainstream science fiction – my first artistic love – for as long as people went on paying me to do it. It does leave my clients a bit blinkered as to the possibilities, though, and I'm always eager to 'extend the repertoire'.

Del's cleavage proved a bit of a problem. The artwork went in a little on the late side (the area of my professional life that still, after all these years, could do with some improvement). For the hardback they simply had to go with the painting as delivered, but for the mass paperback it was decided to pull together the drawstring of her shirt in the name of common decency. Instead of sending the painting back to me from the US a scanned version on a Zip disk was returned instead and I was able to make the change digitally – which was one of the first professional uses to which I put my recently acquired AppleMac.

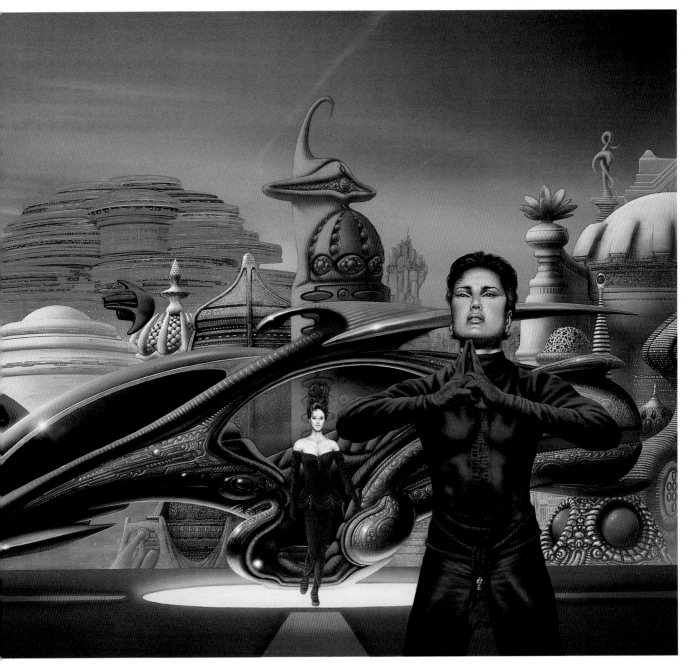

TO HOLD INFINITY

John Meaney

(*Transworld*)

Surely one of science fiction's most impressive first novels to emerge in recent years. Truly original, totally unpredictable, seriously weird. Written in a uniquely individual style and with great confidence and ambition – I long to read John Meaney's next book! I decided to go the full, glaring Technicolor route on this one. John's confidence with the text was kind of infectious – so no muted palettes. Out with the full range of luridly poisonous cadmium reds, oranges and yellows applied in heavy-duty layers through the airbrush. I really should wear my

protective mask more when spraying this stuff. It sits in my drawer – has done for more than two decades – largely unused. Do not follow my example those of you who aspire to becoming airbrush artists! I particularly loved designing and painting the fancy vehicle the girl in the middle distance is stepping from!

My third daughter (following in the footsteps of her mother and two older sisters as cheap, unpaid models) posed her hands for the finger-knitting kuji-kiri, or energy channelling, which Yoshiko, the main character of the novel, is employing here. The facial reference was originally a Western type, but I 'orientalized' her – hopefully successfully. I should have liked to have done some more work on the background of this

painting (true of any number of my paintings actually, but so rarely acted upon). The flying police vehicles could do with some more detailing for a start. However, this painting didn't stay in my ownership all that long. A very enthusiastic John Meaney set his heart on it one day at a convention. I hadn't met him previously – just noticed this guy in quiet yet gleeful contemplation of the painting as it hung in the art show. As I have said elsewhere, it's most satisfying to discover that the writer of the book one has illustrated is as pleased with the result as John proved to be. It's even more satisfying when they fork out good money for it!

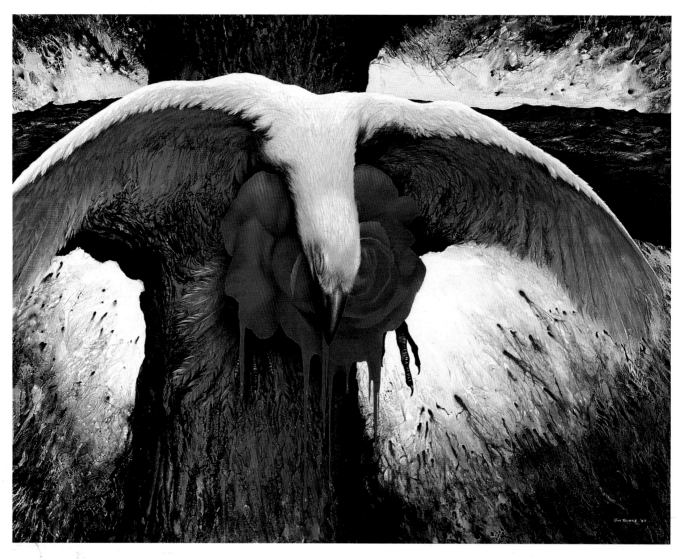

THE SONGBIRDS OF PAIN

Gary Kilworth

(*Unwin Hyman*)

A typical response to this painting when I've hung it at conventions has been 'Were you very depressed at the time, Jim?' or 'What inner demons were you seeking to exorcise in this piece?'. For the umpteenth time the response has to be – 'There are no inner demons'. An illustrator's motivation for painting (this illustrator, anyway) is not the same as that of a fine artist. This is not a tortured soul seeking to express itself through painting. Sorry to be so prosaic folks, but it's true. So a job like this one comes along, a collection by one of the finest short story writers around. It seems that Gary has an idea of his own which might be an interesting cover approach, based

loosely on a painting by (I think) a German artist – essentially a somewhat abstracted vision of a crucified bird if I remember correctly (I've long since lost the postcard of the painting Gary handed to me). The idea was to use a similar visual idea simply as a play on the words of the title. It's not that often that writers get much of a say in the cover designs for their books but it was a pretty enlightened and imaginative regime at Unwin Hyman – and so things moved ahead on this basis. So in effect, this painting has less of 'me' in it than almost anything I've ever painted – despite the fact that most people seem to perceive it as obviously my most personal piece! Which isn't to say I'm not fond of it. One of those paintings that teases one somewhat with regards to 'alternative artistic possibilities'.

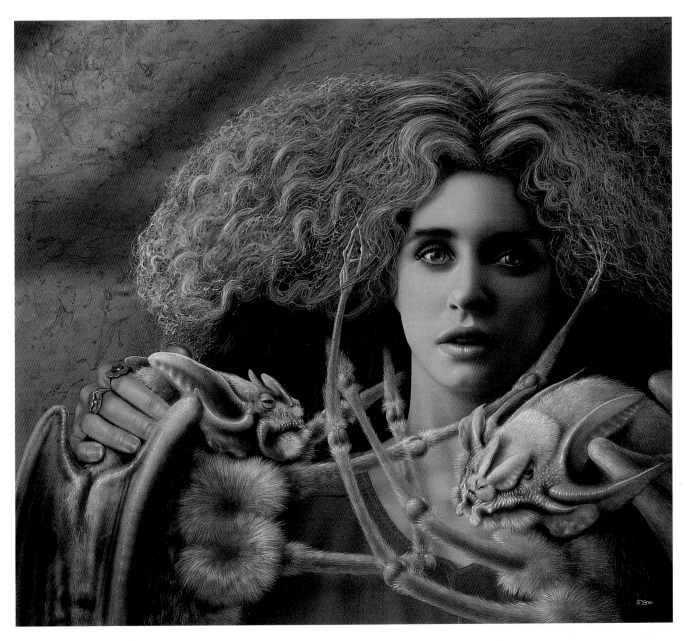

ARTIFICIAL THINGS
Karen Joy Fowler
(*Bantam*)

A superbly crafted collection of short stories from the writer of the book John Clute referred to as possibly the best first contact novel ever written (*Sarah Canary*). The original sketch for this painting evoked a little too much horror in the expression of the young woman, repelled by the friendly enough little creatures who are fascinated by her alien strangeness to them. The art director asked me to give her a more neutral expression. In the end she acquired a kind of preoccupied detachment which is perhaps more appropriate to the collection anyway. It brings a different aura of strangeness to the illustration. As I recall, the creatures are described as something between a moth and a bat – just the kind of launching point I love to get my teeth into! A palette limited to just a few warmish, muted tones, an effective background which is simply some random marks and the suggestion of light coming through a window, courtesy of fifteen minutes airbrush work and some manic scratching with the business end of my faithful old scalpel to lend conviction to the girl's wild hair and. . . hey presto! a not-half-bad painting if I say so myself. Why can I never learn that some of my better pieces (amongst which I include this one) *are* better for the reason that they are uncluttered, essentially simple paintings, the eye not diverted by a plethora of unnecessary detail as in so many of my efforts?

S.ANDREW SWANN

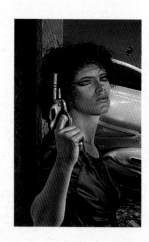

For an author, the process of having an image created from his words can be a delight or a disaster. Jim Burns's work in my case has never been other than a delight. My first glimpse of his work was the cover for my first book, *Forests of the Night*. I was visiting Sheila, my editor at DAW, and had the rare opportunity to see the actual painting.

That painting, while perhaps the most symbolic and least narrative of all the covers he's done for my work (it, unlike the others, doesn't illustrate any one specific scene), happens to be my favourite. My excitement upon seeing that painting can only be compared to my feeling upon my first sale.

A very close second is the cover for *Profiteer*. In it, he had done the most faithful reproduction of an author's idea of an alien that I can imagine (I've wondered how he got hold of my personal notes for the book, and the sketches I had made of Flower, my alien).

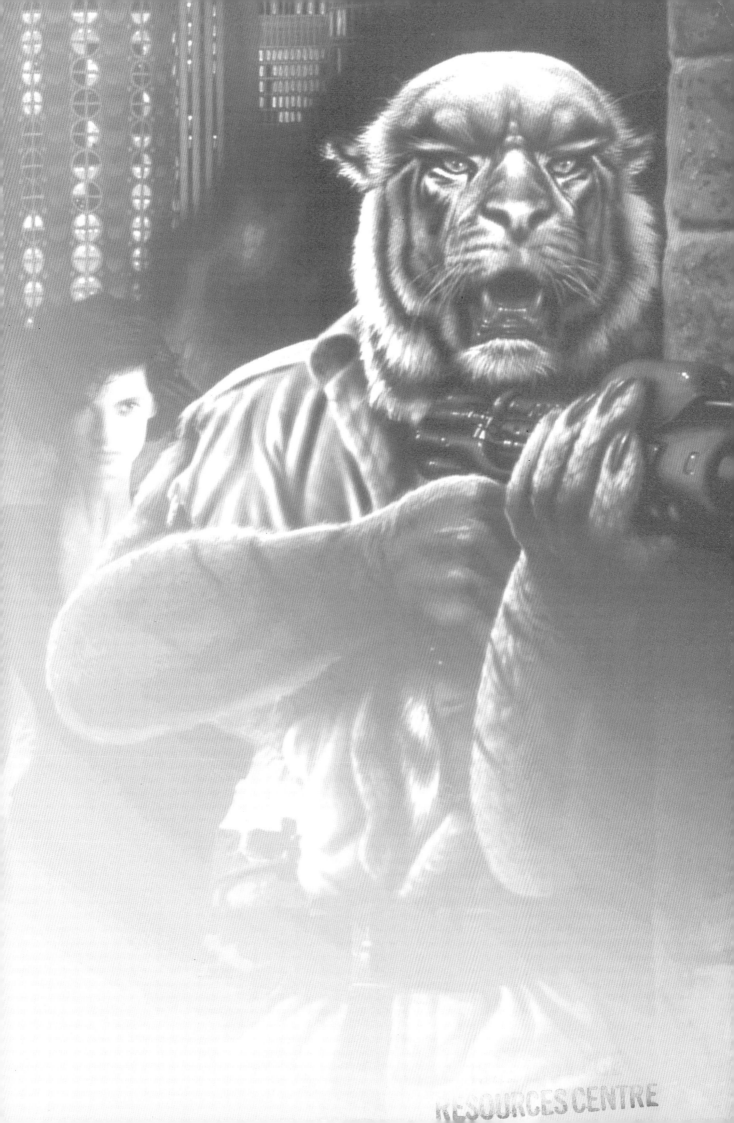

HOSTILE TAKEOVER 1 (PROFITEER)
(*Daw*)

Occasionally I find myself drifting into an unconscious stylistic quirk which I'm sure contravenes some rule or other of good composition – namely to divide the painting into two horizontal bands of contrasting colour. It is particularly extreme in this painting but see also *Hostile Takeover 2 (Partisan)*, *Ancient Shores* and *The River of Time*. It's only when I hold the finished painting up at a distance on completion that the fact suddenly announces itself to me! Nevertheless, the punchiness of the cadmium orange and the almost chemical blues work to some useful effect here. Which is to say that it's eye-catching and that is, in part, the *raison d'être* of book-jacket illustration! It also enhances the strangeness by moving away from a 'natural' or 'familiar' impression – which is, in part, what science fiction is all about.

I posed my wife, Sue, for the woman on the front cover, though I did my old Doctor Frankenstein act with the head. I have a bunch of reference shots showing Sue brandishing my camera tripod in a threatening manner. I hope the tripod has successfully mutated here into an appropriately gee-whiz firearm!

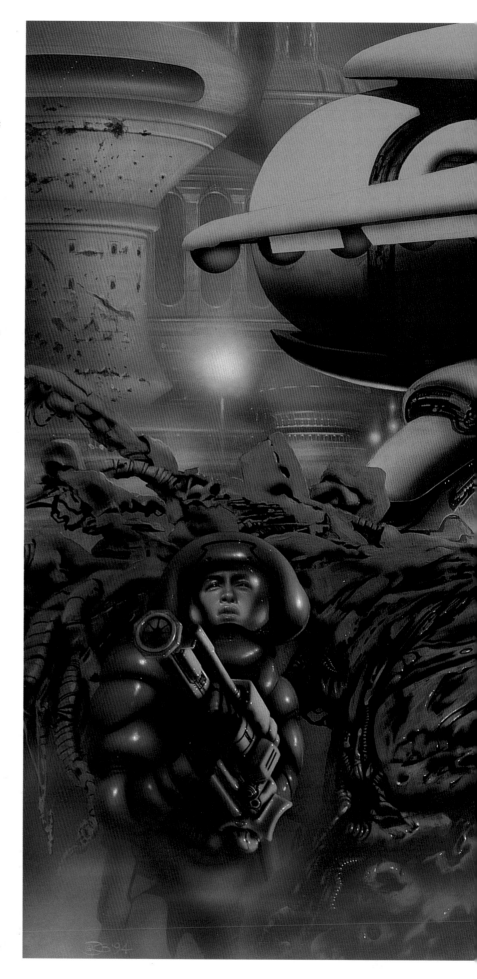

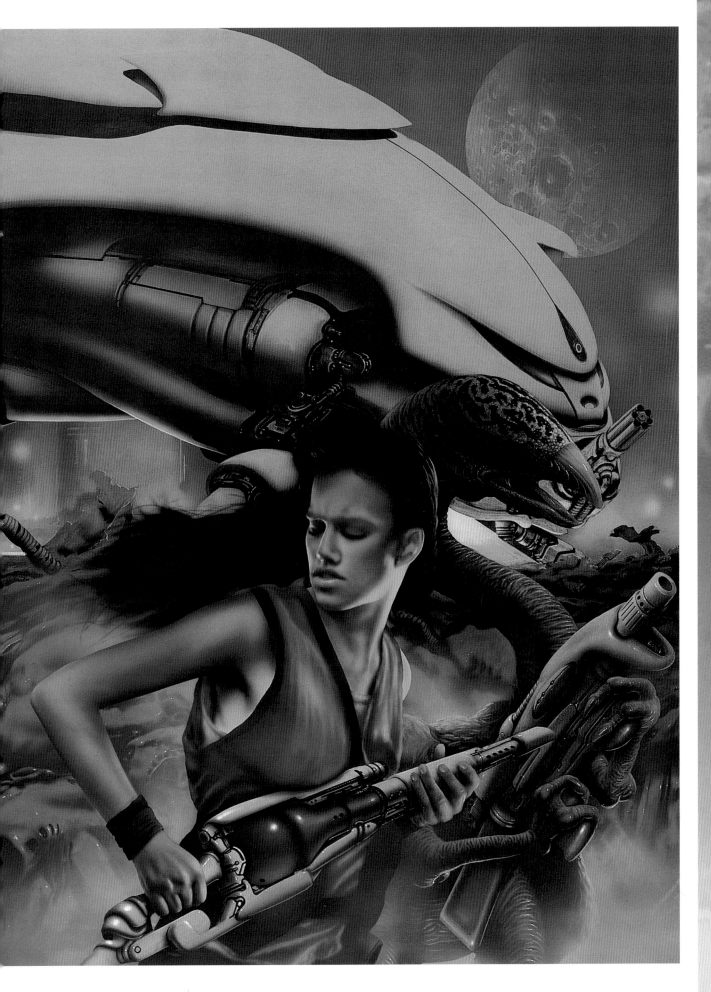

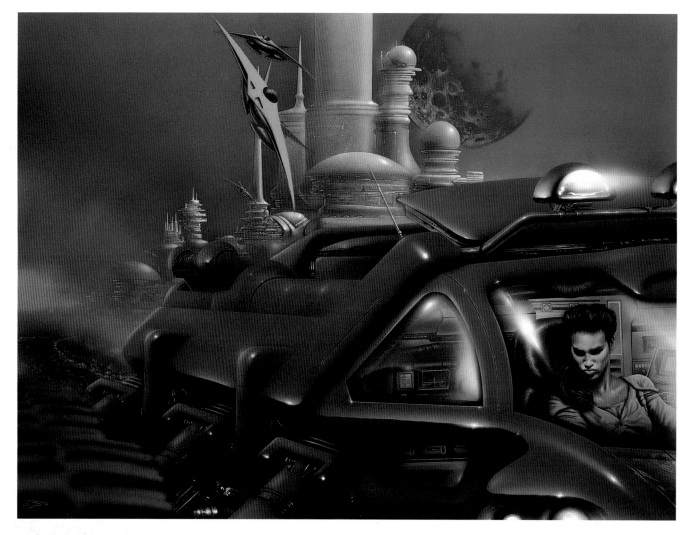

HOSTILE TAKEOVER 2 (PARTISAN)
(Daw)

Our feisty heroine again, this time manhandling a large vehicle across the unfriendly terrain of the planet Bakunin. Equally unfriendly are the green aircraft pursuing her. The original version of this painting had a completely different colour scheme. The red vehicle was actually painted in a sort of beige, desert camouflage and looked rather understated. The pale bluish buildings in the background were also more muted and indistinct. It was a decidedly 'subtle' painting with a limited and rather bland palette of colours applied. The client liked the image but wasn't at all sure about the lack of punchiness and so asked me to brighten things up a bit.

It's sometimes the case that when a client requests changes I feel in my heart of hearts that it's a peculiarly retrograde step. More often it"s a slightly pointless lateral side-step. But just occasionally the art director is so right! A somewhat indifferent painting was turned, as a consequence, into one I was distinctly pleased with. The saturated blood reds and oranges made the vehicle suddenly so much more dynamic, pulled right to the foreground of the picture and seeming almost to drive off the canvas and into one's lap. There's a lot of airbrushed glazing going on here, adding to the smooth solidity of the machine and contributing interest to its surfaces. The sun on the horizon was made much more vivid and its light was reflected off the central buildings. The picture really sprang to life.

FORESTS OF THE NIGHT
(*Daw*)

S. Andrew Swann does present an artist with some great material to work with. Imagine a sort of SF/*noir* story about a private eye investigating a murder. Then make the private eye half man, half tiger, the dubious consequence of experimental gene manipulation. I suppose on a computer with an appropriately clever piece of software one could very easily morph a human and a tiger and come up with something effective very quickly. Well, at the time I had no skills with a computer at all (more to the point, I had no computer), and so I had to attempt the fusion in a more traditional way.

And what a fun project it was! One could approach a task like this in one of three ways, I imagine. You build up a composite human/tiger from scratch. You take a man's face and pull and push at his extremities towards a 'tigerish' aspect (the way I very often create my more humanoid alien types), or you could take a tiger and humanize it. I elected to follow the latter route this time round and at the end of the day I felt that my creation was pretty close to how I imagined Nohar Rajasthan the tiger-man might look. I always felt that his tiger side threatened to overwhelm his more human side and an intelligent-looking, bipedal tiger seemed more 'right' than a feline human.

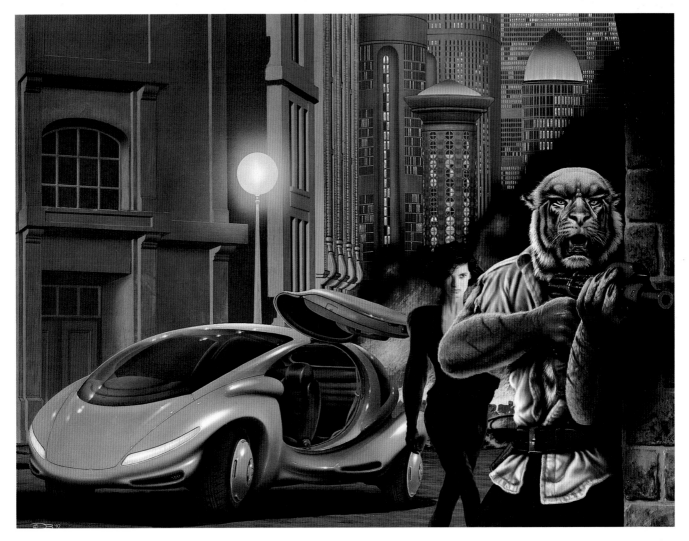

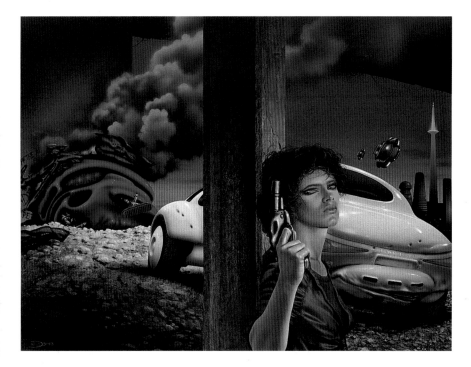

EMPERORS OF THE TWILIGHT
(*Daw*)

The second part of the thrilling trilogy that started with *Forests of the Night*. A different strand of genetic tinkering – more accurately physiological bio-engineering – producing enhanced strains of human beings. Result: our cat-eyed agent heroine, Evi Isham. My long-suffering wife, Sue, again posed for the picture, coolly clutching a toy pistol, but once more found her own head removed and that of another woman taking its place. My own form of Frankenstein creation!

SPECTRES OF THE DAWN
(*Daw*)

The final part of the trilogy that started with *Forests of the Night* and continued with *Emperors of the Twilight* – and probably the most bizarre of the three! This time our 'moreau' – the animal/human composite – is half girl, half rabbit. The original role of this particular chimerical variant is of dubious propriety to say the least, but, this being understood, I found myself with a bunch of interesting self-imposed parameters to try to work within. I say 'self-imposed' because nobody told me that I had to include our bunny girl! But it's just the sort of challenge I enjoy. Firstly, she has to be obviously part human (easy enough) and part rabbit – not mouse, squirrel or any other rodentine form. (The big floppy ears make this a pushover.) Secondly, she should seem vulnerable (big, black bunny eyes help enormously) but also streetwise, a tough little cookie. (Putting a compact-but-feminine, human-albeit-furry body on her pulls her out of the meadows and onto the streets.) Thirdly, there should be the subtle and slightly dangerous suggestion of appealing sexuality (remember this is the perverse future, not the good ol' homely 20th century), At the same time, the dictates of dubious science have created a being which from our perspective would be horrific – so an undercurrent of repulsion should also be evident. Lastly, and most difficult, was to avoid what I called the 'Bugs Bunny Syndrome'. A human bunny rabbit, for goodness sake, with the teeth and the ears! Easy to see how one could fall into a decidedly comical trap. I don't know if in the end I succeeded, but I

have a soft spot for Angelica Lopez, my peculiar little rabbit girl.

A brief technical point regarding colour. The rosy glow on Angelica and the guy with the elongated skull and fingers (who deserves all he gets, by the way!) was applied after I'd finished the painting in acrylics by spraying well-watered glazes of drawing ink onto the surface of the paint. It seems to sit perfectly happily on the paint and –

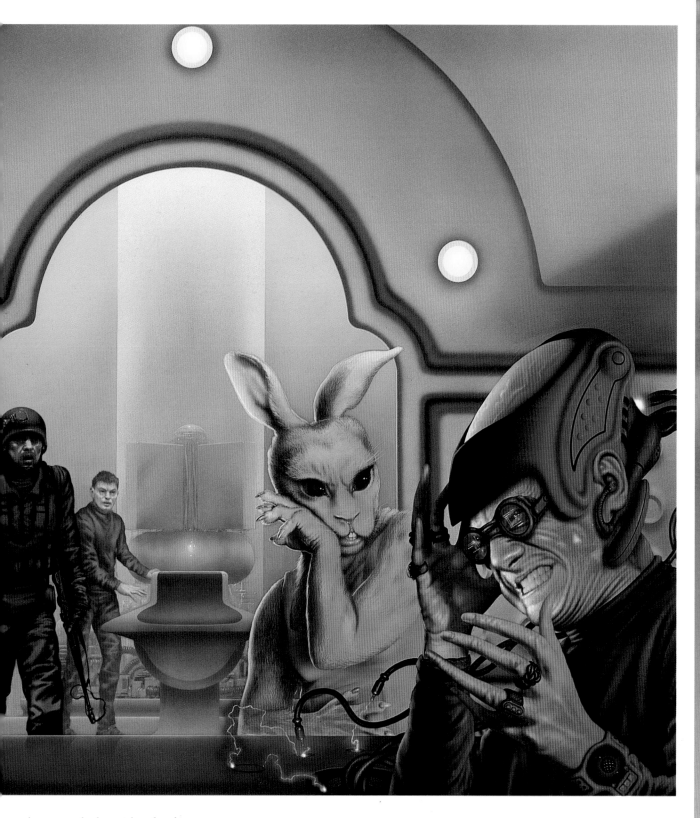

when properly dry – takes the gloss and matte mediums I use for varnishing very readily. Inks are a good way I've found of providing a 'lift' to the sometimes slightly 'dead' surface of acrylic paint. I've used the technique quite a lot in recent years and it's definitely brought a new vibrancy and richness to my work.

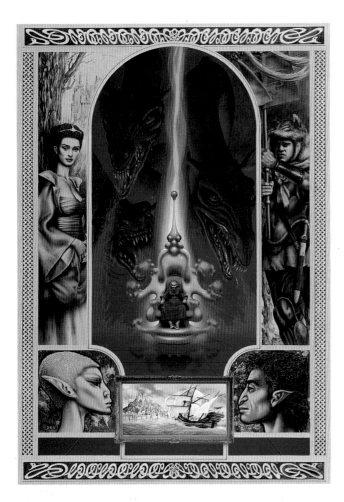

hard science fiction – which at least engages the brain as well as the emotions.

Phew! I'm glad I've got that off my chest. Back to the books at hand – which do stand out as original and different – I enjoyed producing these four paintings as much as anything I've done in the last decade. I took what might be considered a fairly generic approach to fantasy cover design. This tends to be more decorative in style with less emphasis on a single narrative incident. I've tried to incorporate in each of the four jackets a 'moment' from the narrative – more to evoke atmosphere and place than a specific incident. Around the edges of the central panels I've adopted a pattern which I stuck to for all four books – a couple of the more interesting characters to either side of the central panel against a little bit of background; another pairing of specific characters done as little cameo-style profiles below the central panel and between these inward-facing profiles, an artefact of some sort which has a particular relevance to the book. Everything surrounding the main central panel is treated in a monochromatic way whilst the central panel itself is in full colour.

Left:
A HANDFUL OF MEN 1: THE CUTTING EDGE
(*Del Rey*)
In the central panel I've put the little wizened form of the old Imperor. He sits in the Opal Throne, the most powerful being in all of Pandemia. My wife, Sue, has a ring with a big fat opal set into it which I used as an unlikely reference for the throne. In the background, dragons loom threateningly, a warning of the chaos to

Dave Duncan is a Scottish-born writer who has lived in Canada for the last forty-plus years. The four books that make up his *A Handful of Men* quartet, given that I'm not usually all that drawn towards fantasy material, (a hard science fiction man, me) were a delight to read, being densely and wittily written with a roller-coaster plot that is sustained unflaggingly through all four volumes. It has to be very good and preferably rather off-beat fantasy to hold my attention, I assure you. I know there is good and bad writing in all areas of book publishing, but it seems to me that Tolkien in particular has a lot to answer for! I am aware that *The Lord of the Rings* is a great work of literature. It must be – because people whose opinions I respect have told me so. To come clean here – I've never read *The Lord of the Rings*, and I have doubts that I ever will now. Another omission is *War and Peace* and quite honestly, in a very busy life in which I seem to have very little time for reading for pleasure and have to make considered choices, if it came to choosing between those two great works my choice would be Tolstoy every time. It doesn't have dragons for a start, which is immensely helpful to me! I fail absolutely to understand what this dragon thing is all about. The damned things seem to drive some people crazy with delight. Anyway, to bring this little personal rant to a close (and to gird up my loins in anticipation of the struggle to come as I will now be obliged to defend my pitch at conventions and the like!), I reckon there are just too many people out there trying to be Tolkien and somewhere the notion of originality seems to have gone out the window. I despair when I see the rows and rows of interchangeable fantasy titles on the shelves. I cannot for the life of me understand why, according to the statistics, fantasy of the Tolkien-derived variety is so much more popular than what we might loosely term

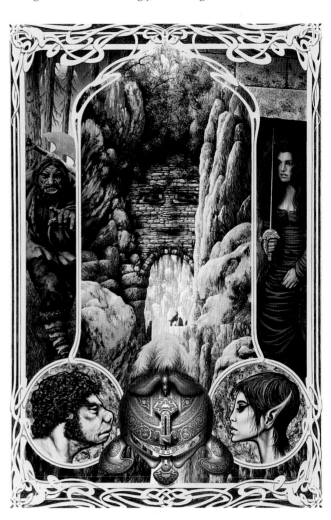

come. Despite what I've said about dragons before, I don't mind actually painting them! The beautiful Queen Inos occupies the left-hand panel and there is a profile of her faun husband, Rap (the ex-stableboy) on the bottom right. We follow the particular personal fortunes of these two main characters through the whole quartet.

Opposite page, below:

A HANDFUL OF MEN 2: UPLAND OUTLAWS

(*Del Rey*)

By the second volume, chaos is definitely descending on Pandemia and the recently installed new Imperor, Emshandar V, has been driven from the Opal Throne by the dwarf-sorcerer Zinixo. My favourite little painted section of the four paintings is the highly ornamented bronze helmet between the two profiles. I got totally engrossed in all that fancy metalwork and spent far longer than I should on it - and the deadline drew closer! The rocky arch of the central panel is supposed to suggest a not-very-friendly face. Dangers lie beyond!

Below:

A HANDFUL OF MEN 3: THE STRICKEN FIELD

(*Del Rey*)

Pandemonium in Pandemia! Zinixo has taken the throne and his reign of terror has started.

I think this is my personal favourite of the four paintings – though occasionally I gravitate towards *The Living God*.

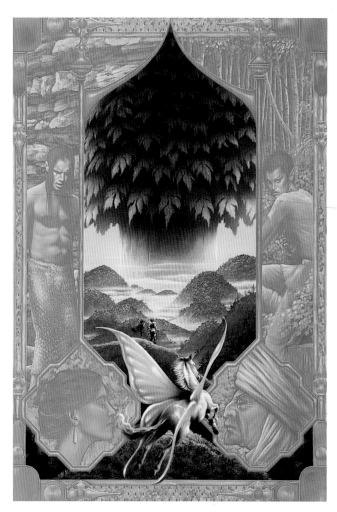

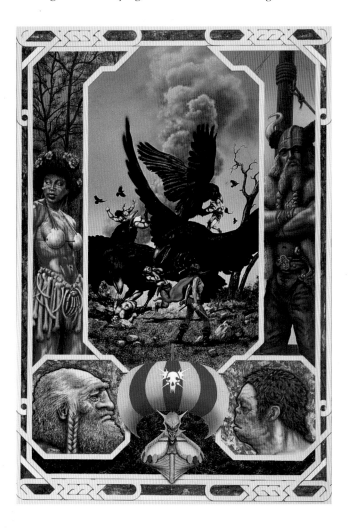

Sometimes I do get myself into little spots of minor bother with editors – and this painting was a case in point. A consequence of taking the text very literally really. What a writer can get away with in words is often trickier to defend in an in-your-face illustration. To whit, the saucy and erotic charms of the girl in the left-hand panel. She is black, she is half naked and she is a cannibal – already we're into iffy territory on the old political correctness front. Dave goes on in glorious detail describing her frizzy hair, her tattoos, her human half-skulls bra, her skirt of human long bones, the bone through her nose. Surprisingly perhaps, the art editor let all this through – but drew the line at her perfect row of sharply filed teeth!

Above:

A HANDFUL OF MEN 4: THE LIVING GOD

(*Del Rey*)

There are quite oblique references throughout the quartet to beings who correspond to our own mythologies and fairy tales. So there are imps, goblins, fauns, pixies, mermen and so on. They have some of the physical characteristics of these creatures but at the same time appear essentially to be men or some variety of men. I've tended to concentrate on these beings in the various subsidiary panels in all these pictures.

With Zinixo declaring himself the Almighty we arrive at the final chaotic denouement of the tale and the end of a very entertaining read indeed. Slave-sorcerers are practising their vile magic everywhere. Goblin hordes wreak havoc and the omnipresent threat of the dragons becomes real as they take to the air incinerating whole armies at a time. Our great hero, Rap the faun, has his work cut out, but in the end good, of course, must prevail.

31

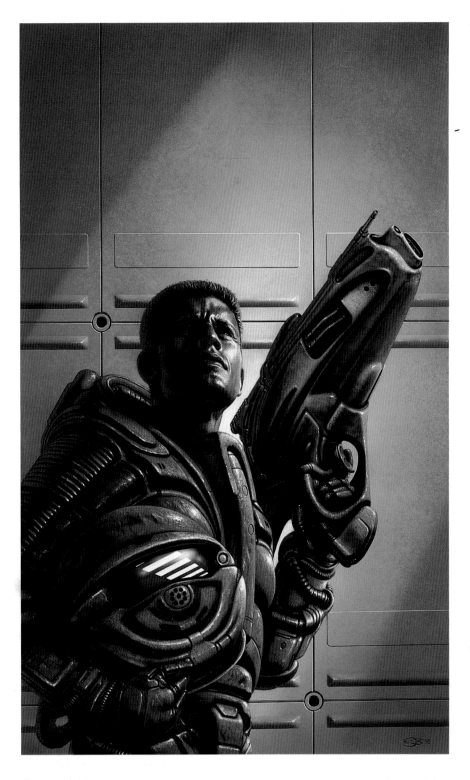

ARMOR
John Steakley
(*Daw*)

The idea of virtually impervious body-armour is a favourite device of science fiction writers from Robert Heinlein's *Starship Troopers* through Joe Haldeman's *The Forever War* and *Mindbridge* and on to this excellent example of that particular sub-division within the genre that explores the de-humanizing effect of war. Well-written military SF can make for very exciting, but at the same time, thought-provoking reading and this novel is most definitely both of those things. I suppose the idea of the 'body amplification suit' is not just a fictional one – well, I know for a fact it isn't because I saw an iffy (but still thought-provokingly scary) US army prototype on *Tomorrow's World* or some such similar programme. Many of the ideas that first see light of day between the pages of science fiction novels eventually come to pass and some, of course, never will (any bets on FTL flight anyone?) but if ever there was a pretty sure bet for the probably quite-near future it's the notion of the 'augmented soldier'. My sketch showed a much, much heavier-duty suit than the painting. However, the art director decided that the soldier's head poking out of the neck-ring looked jokily small in comparison to the vast suit he was wearing, so some of the bulkiness got sacrificed – though I think in paint I could have got away with it. The painting was completed in a virtually monotone blue-grey. It was only as an afterthought that I added the red illumination which definitely made a huge difference to the quality of the finished piece.

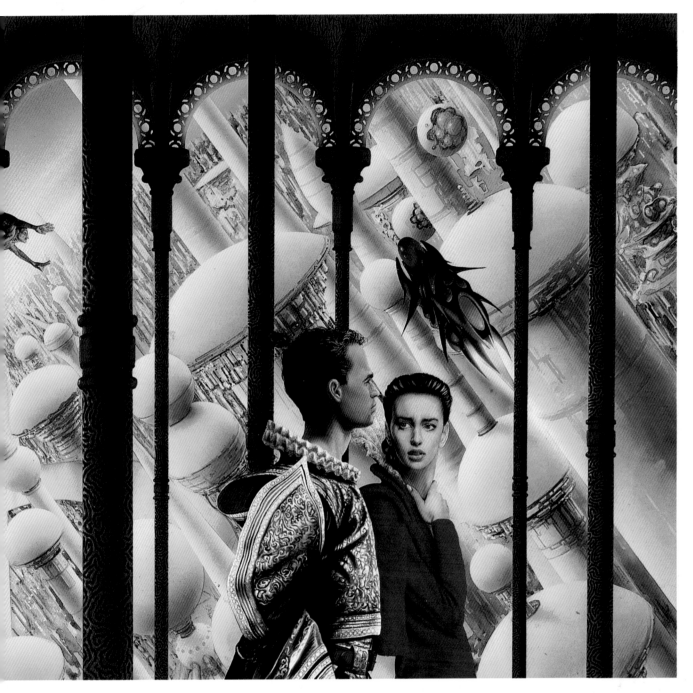

ARISTOI
Walter Jon Williams
(*Tor*)

A largely non-dystopian – just for a change! – view of what is to come in which Humanity seems in large part to have got its act together. Non-dystopian doesn't necessarily mean utopian, of course, and there is, inevitably, the fly in the ointment in the form of the renegade Aristoi who rebels against the kind of perfect future hinted at in Walter Jon Williams's remote vision of futurity. It's all here, nano- and bio-technology, terraformed planets, interstellar empires, – virtually all things are attainable in a time when Humanity is able to manipulate the fabric of existence to his bidding. The notion of the Oneirochronon, a sort of shared virtual reality which excitingly legitimizes the notion of multiple personalities within an individual, is particularly well conveyed. One of those books which leaves one grasping at a myriad possibilities for the cover art. In the end I was drawn to the simple visual device of trying to convey the sense of harnessed gravity (no easy task) by simply skewing the background at forty-five degrees to the foreground. Whether or not it comes off I'm just not sure. The cosmos has become an infinitely manipulable backdrop for the playing out of the human drama.

THE HOUSE ON THE BORDERLAND
William Hope Hodgson
(*New English Library*)

I very rarely tackle horror or 'dark fantasy' themes. Not because I have any particular personal resistance to the genre – though I can't pretend to any great enthusiasm for the more emetic, in-your-face modern idiom – but rather because I don't think I'm terribly good at it and I hardly ever receive these types of commissions. But every so often somebody decides to give me a crack at one and I'm obliged to sit and read the thing, as in the case of *The House on the Borderland*, and I discover a great book by a great writer. (Though more than twenty years before I'd completed a cover by the same writer – *Carnacki the Ghost Hunter* which was so bad, the painting that is, that I'd

effectively excised the name from my memory.) There's no two ways about it – this book is a true classic, haunting and shocking and not quite like any other book I've ever read. It has the added poignancy of being a work by a writer whose massive potential was extinguished – like so many others – by the ghastly ravages of the Great War.

ANCIENT LIGHT
Mary Gentle
(*New American Library*)

I went up to Mary Gentle once at a convention and asked her what she thought of the American hardback cover for her new novel, *Ancient Light*. She and I had never met before and she had no idea that I was the bloke who'd painted it. A rotten trick I know, but often the only way to get an absolutely truthful answer! It served me right I suppose to get a not-overly enthusiastic response, but even when I revealed that I was the

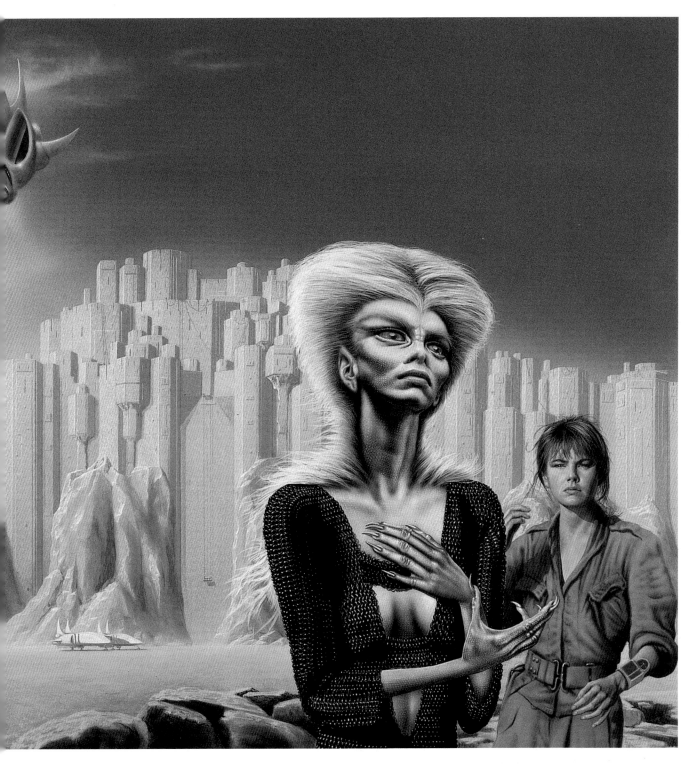

artist she remained wonderfully unfazed and proceeded to explain that she had lived with the characters from *Golden Witchbreed* and *Ancient Light* for many years and that there was no way that the Orthean character who features in the forefront of my cover would wear chain mail. I probably blustered and demurred a bit. After all, aren't I supposed to be the SF artist who reads every word, makes copious notes and tries to stick as closely to the narrative truth as possible? I could have sworn there had been mention of chain mail and so that pernickety, pedantic little streak in me required that

I consult the book at the first opportunity. Of course, Mary was right. The half-crazy alien woman Calil bel-Rioch doesn't wear chain mail. It's metal mesh! Or scale-mail. Or some such. This fastidious attention to tiny minor details is one of the things I love about so many SF writers and their literary creations. It's so at one with my own obsession with visual detail. But woe betide me if I get it wrong!

Ancient Light is, to quote Mary Gentle, '. . . a Jacobean drama on another planet . . . set in an alternative future where the British Empire never collapsed'. Certainly an intriguing premise on which to

build a novel. I loved this book and its enormous subtlety.

I truly enjoy painting these almost-human alien types, particularly female examples where a bit of a tightrope has to be walked between the repellent and the alluring. I usually start off – as in this example – with a piece of human reference and then adjust it, almost as if one is moulding a piece of clay, towards the impression of the being as described in the text. Also it's one of those near-monochromatic paintings which I find such a relief after the occasional chromatic overkill of some of my work.

JACK McDEVITT

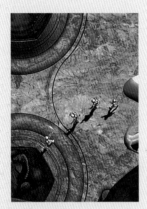

Mood is everything. There's a sequence in *The Engines of God* in which the explorers have discovered a long-abandoned alien space station. I wanted something other than the standard wheel whose deteriorating grey skin had grown mottled and taken a few meteor hits. Something *alien*, yet familiar enough that the reader would get a sense of *place*.

The station was brick-red. It looked like a run-down factory, cluttered with struts and joists and supports and turrets. And big. *It had to be* big. With a rusted-iron feel, the sort of thing that, save for its size, might have been lying around on Chicago's south side in the 1930s. An orbiter, in other words, with weeds growing around it.

I was delighted to see Jim take the challenge. The problem was to get the sort of detail that its seediness required, and still manage to suggest the sheer mass of the thing.

In his *Terran Derelict*, an alien explorer examines a wrecked vessel. We know the vessel is big; we can feel it. And we know it is very old. We can't see much of it, but Jim draws the ravages of time like no one else; and he provides a sense of mass by what he withholds, what we *don't* see.

He uses the same technique with *Engines*. A few astronauts have landed on the object. They are visible from a range that renders them so small as to be almost inconsequential. Even their substantial shuttle is dwarfed. Yet we know we are looking at only a minuscule fragment of the station. It is the rest, offstage, that weighs on us with its sheer mass.

Ancient Shores provided a different kind of challenge. It's a lighter novel, featuring a North Dakota stargate and an idyllic world on the other side.

Jim went after the playful, and occasionally exultant, mood of the book, capturing its two major characters at a pivotal moment. She's been missing; he's annoyed, has just made his first trip through the stargate, and has not yet quite zeroed in on where he is. It's probably not necessary to read the novel to know that the ethereal bubble in whose entrance he stands is a kind of cosmic train station. The landscape is otherworldly lush in the finest tradition. Stars crowd the sky, and rousing discoveries lie ahead.

Jim's special gift, in my view, is to capture the essence of either a critical moment, as in *The Engines of God*, or of an entire novel, as in *Ancient Shores*, and get it onto canvas. That's a long way from just reproducing starships and ringed worlds.

Above:
THE ENGINES OF GOD
(*HarperCollins*)

What a great job interstellar archaeology would be! And what a wonderful mix of stuff for the artist – a combination of great, highly imaginative, hard science fiction coupled incredibly neatly with exploration of the exotic, Howard Carter variety.

This is a biggish painting – about four feet long – but kind of skinny at only twelve inches high. The constraints put upon one by the largely unvarying format of the book jacket can become a little limiting at times, so I welcome the occasional opportunity to work within an unconventional frame.

I wanted to establish a dramatic contrast between the two spacecraft. The Earth shuttle is small, freshly painted, rounded and friendly, docked nose-down against a section of what is obviously a very much larger alien artefact. The artefact is a relatively unsophisticated structure, tens of thousands of years old and gradually ablating away beneath a steady rain of micro-meteorites. Internally it proves to be a veritable deep-space Tutankhamen's tomb, and the description of the vacuum-desiccated aliens strapped to their seats is incredibly evocative. The complex textures of the surface of the alien space station were quite rapidly accomplished by a simple airbrush technique I've created for myself whereby a (usually) transparent colour – in this case burnt sienna – is sprayed or painted on in broad random swathes and then, whilst it's still dampish and vulnerable, I liberally drip clean water and spray high pressure air over the pristine airbrushed surface. As random formations begin to resolve themselves I start to identify potentially interesting shapes and 'harden up' the serendipitous revelations into something resembling the final structure. In this particular painting I then added shadow tones in burnt umber and highlights of whitened burnt sienna and white to lend tonal conviction and a hopefully photo-real finish to the craft. It's a lazy but effective technique.

Opposite page:
ANCIENT SHORES
(*HarperCollins*)

Over the years my use of colour has changed quite markedly. Initially it was very restrained – not through a subtle appreciation of mellow tone or restricted palette, but through sheer timidity! Whilst at art college, I rather painfully tormented images out of the paper with coloured pencil, a technique which in the hands of a master can produce wonderfully subtle results, but as a medium for producing punchy science fiction images for book jackets is decidedly understated. Though I turned to gouache quite rapidly (since superseded in my personal repertoire by oils, acrylics and now, to a growing extent, digital media), I retained the tendency to repress the colour drama of my paintings for a long time. These days I have an almost care-free inclination – on occasions anyway – to saturate the painting with colour to the point where I almost start to flirt dangerously with the downright gaudy. This painting is such a case, where almost the entire palette has been slung at the canvas in order to try to convey a sense of the exotic. Whilst the results of such manic excess can sometimes be as counterproductive as my more diffident efforts, this time round I kind of liked the finished piece. The jarring shades of red and green, yellow and purple on the front cover, to my eye anyway, satisfactorily managed to convey the feeling of a truly alien place beyond the gateway to another world found within the 'Roundhouse' of the tale. It would have been more effective in the final printed version had the publisher not decided to excise the Horsehead Nebula completely from the image!

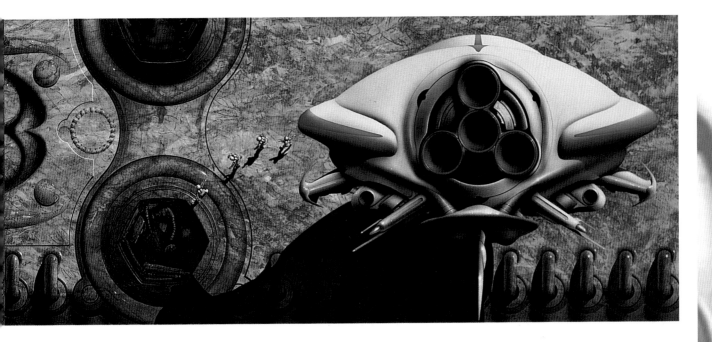

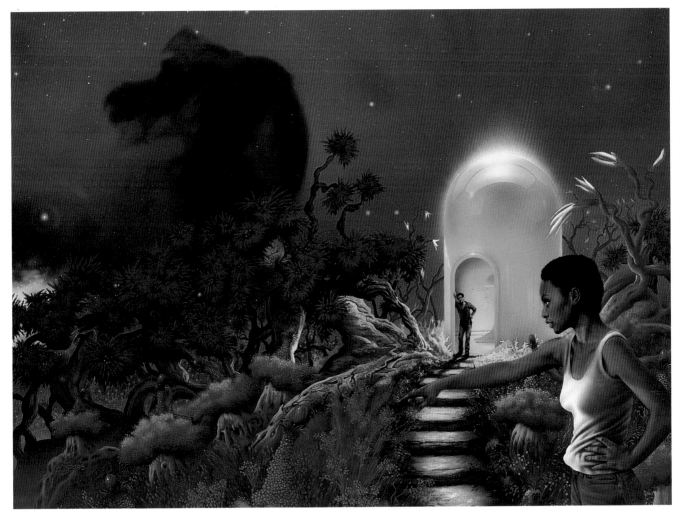

It's hard for me to think of David Wingrove's eight-book saga of a Chinese-dominated future as anything other than the most monumental writing achievement within generic SF of the last ten years. It is almost unbelievably ambitious in its vast scope and the most amazing thing is – it's a first novel! I suppose no book is flawless, this series included, but on the whole it's a truly literate accomplishment (can't say that of all SF!) and, if life was fair, even if David never wrote another word, this should have earned him a place amongst the genre's greats.

The whole saga presumes a rise to global pre-eminence of a Chinese superpower, which totally, and with great harshness, exercises its absolute rule over a world in which most races other than Caucasian (referred to as Hung Mao) have been ruthlessly exterminated. The political mechanisms the Han (as the Chinese are referred to) use to maintain the huge and increasingly shaky edifice of their world culture is a post-Communist amalgam of Western-derived technology and a revived Confucianism. How on earth David managed to sustain the juggling act with the myriad well-drawn characters and plot lines is a marvel to contemplate really!

Obviously no shortage of material to illustrate! I eventually produced the covers for the first five volumes of the series. For some reason or other, the remaining three were given to other artists. A bit of a shame as I would have liked to have completed the full set, but you can't have everything! I produced two different covers for Book 5 (*Beneath the Tree of Heaven*). If I remember correctly, Dell in the US considered the UK cover to be too reminiscent of the cover for Book 1 (*The Middle Kingdom*) and I was invited to have a rethink. This has only happened to me once before – well, three times actually, as it was a kind of trilogy – with the first three volumes of Robert Silverberg's *Majipoor* sequence – but then it was simply a case of the desire on the parts of the publishers for different covers for the US and the UK.

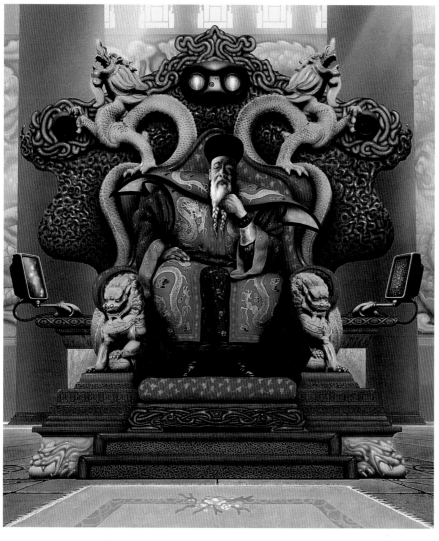

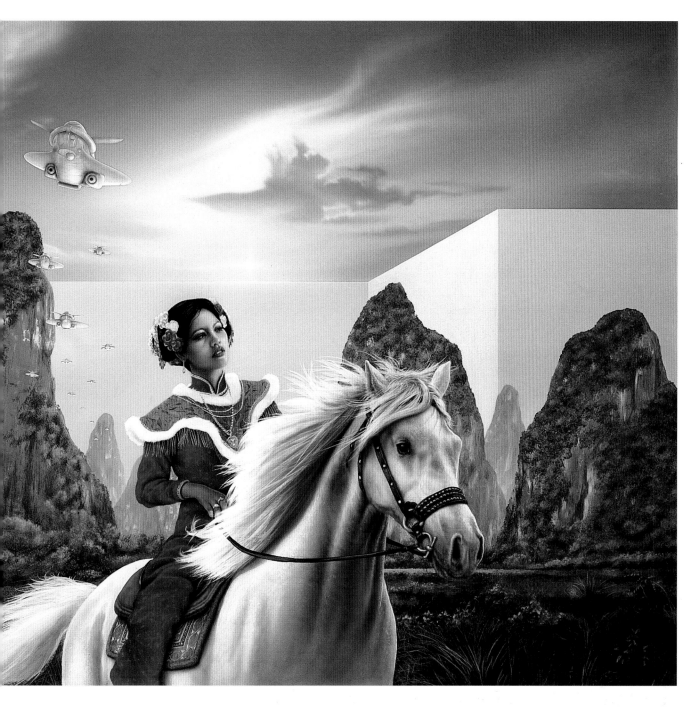

Opposite page (detail) and p42 top:

CHUNG KUO 1:
THE MIDDLE KINGDOM
(Dell)

The first book in the mighty epic ('CHUNG KUO' means 'MIDDLE KING-DOM') and my personal favourite of the six paintings. I was immensely pleased with the old emperor in his somewhat high-tech throne. In the background we can see a vast holographic projection of the Earth whilst behind that, huge dragon murals in a traditional Chinese style can be seen through the beams of sunlight coming from above. One of the dragon's stylized heads appears by accidental conjunction to be about to take a bite out of the Earth, which was a

deliberate (but too subtle, since it's rarely noticed!) little compositional device of mine to convey the notion of the hold the Han have over the planet.I took a long time over this painting and was very pleased with the final result in which I felt that I'd managed to combine reasonably successfully a sense of traditional China with a suggestion of the future.

Above:

CHUNG KUO 2:
THE BROKEN WHEEL
(Dell)

The same intention here really with the girl in her traditional, pretty Chinese costume (which reminds me; David Wingrove once lent me a rather classy

tome on Chinese fashions down the ages as reference material for these books. I really should, after nearly a decade, return it!), contrasting with the futuristic flying machines above and the cryptic and rather forbidding edifice in the background – the three-hundred-level-deep City, five examples of which pretty much cover the entire land area of the major continents. In the middle distance are sharply rising tree-clad limestone mountains of the kind encountered in the Guilin area of China and so evocative in the imagination of the beautiful landscapes of China – but here dwarfed by the brutal exterior of the City.

41

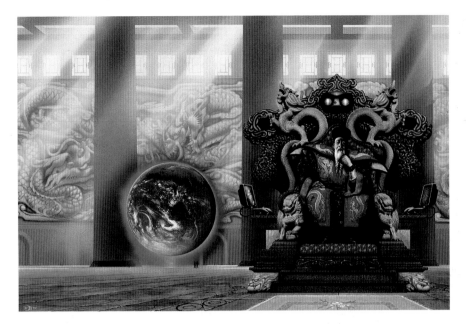

Left:
**CHUNG KUO 1:
THE MIDDLE KINGDOM**
(*Dell*)
see page 41.

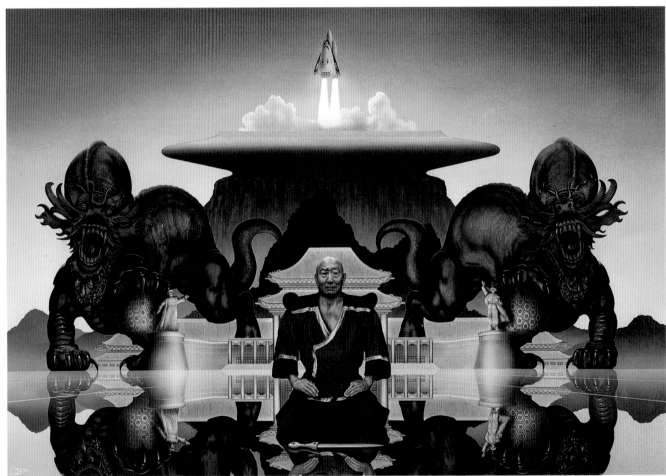

CHUNG KUO 3:
THE WHITE MOUNTAIN
(*Dell*)

A pattern was developing in my approach to these covers. Namely, the contrast between the wonderfully exotic traditional aspects of pre-Communist China and a high-tech future in which the solar system is gradually being opened up – albeit rather slowly under the inward-looking Han regimes. In the foreground, the dignified-looking Chinese is about to commit a very public ritual suicide on the viewscreens of the world. In the background, a shuttle takes off from a spaceport which I've tried to give a Chinese flavour in its building shapes and the huge guardian dragon statues either side. I've attempted to create what looks like a highly reflective plane in which we can see the exact reflections of the spaceport and the suicide – not because there's any mention of such a reflective surface in the book, but because sometimes one needs to emphasize with simple devices the fact that this is a science fiction novel. This fact occasionally gets a bit lost as one attempts to be subtle and sensitive!

Chung Kuo 4:
The Stone Within
(*Dell*)

In Book 4, I've dispensed with the traditional/futuristic interface and basically painted a Chinese soldier of the future. We are told that the technology of the time (about 200 years into the future) is essentially old American-derived stuff and one gets the impression that technological progress has in some ways slowed down. So I wanted the shuttle in the background to look like a fairly near-future development of the kind of design-think-ing we have now – although since painting this and having seen pictures

of the soon-to-fly X-33 it's obvious to me that I'm not moving as fast as the real world here! Look closely and you'll see the suggestion of some dragon-style ornamentation in the soldier's uniform, and the re-curved shoulder pads also add an Oriental flavour. I felt that the rather mild hint of an epicanthic fold was probably not sufficient to carry the essentially Chinese theme forward so gave the picture some extra help with these uniform tweaks.

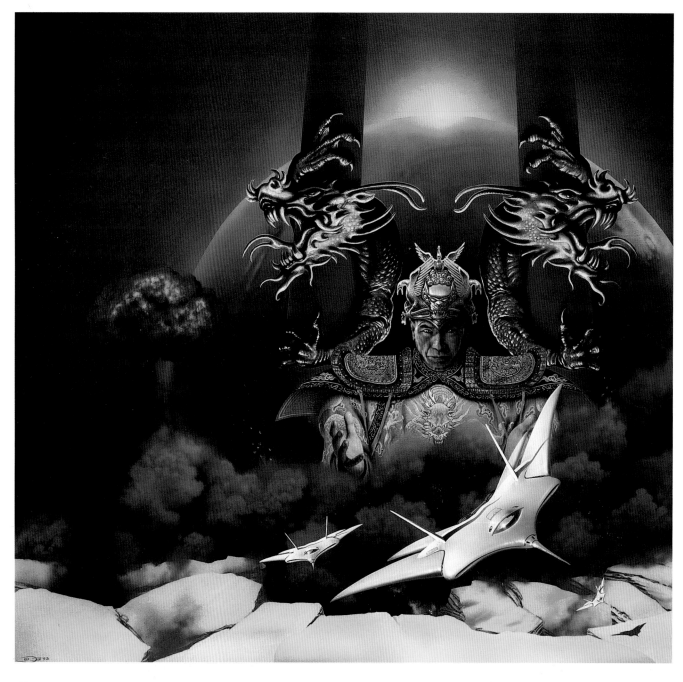

Above:

CHUNG KUO 5: BENEATH THE TREE OF HEAVEN
(UK – *New English Library*)

In the illustration for the UK version of *Beneath the Tree of Heaven* I reverted to the approach I'd taken with Books 1 and 3, focusing on a traditionally garbed high-ranking Han type. I fell back quite heavily on David's fancy Chinese costume book here, the clothing being loosely based on Qing dynasty military armour (the last dynasty before the 1911 Revolution) and the headgear being closely modelled on the court crown of Prince Zhong of the Taiping Heavenly Kingdom, Qing Dynasty.

Below the silver stealth craft we see sections of the City fracturing under aerial assault. The greatest empire the world has ever seen is beginning to crumble!

Opposite page:

CHUNG KUO 5: BENEATH THE TREE OF HEAVEN
(US – *Dell*)

This was the cover I painted for the US version of Book 5 – a completely different approach and nearer in spirit to *The Stone Within*. Part of the action has moved to Mars, where rebellion is being fomented. The special Mars breathing suits were fun to paint, but this picture, happy enough as I was with the result, somehow seemed to have lost the Chinese element completely!

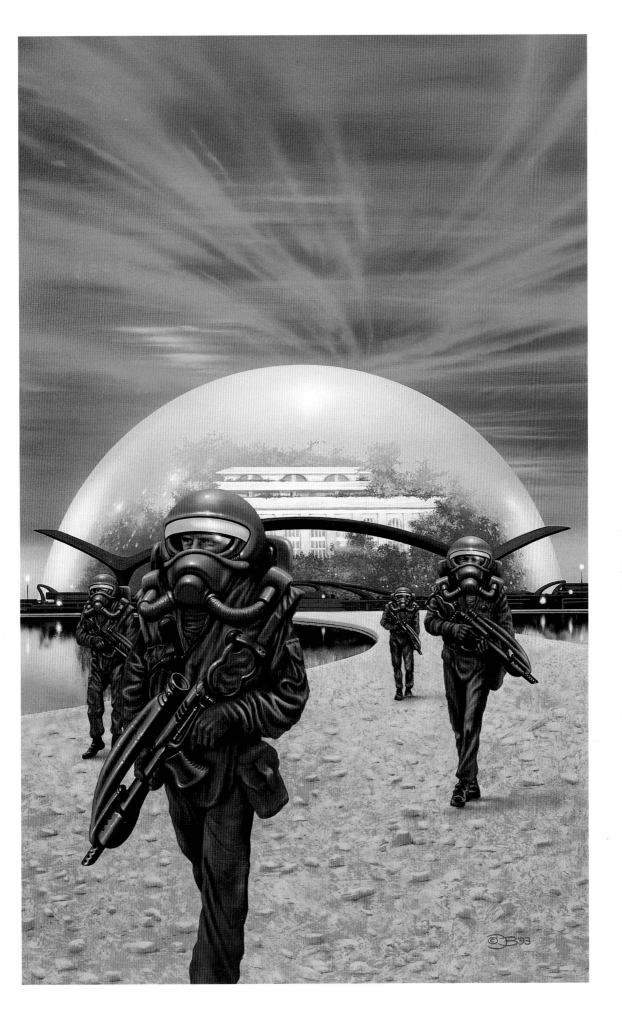

PAUL J. McAULEY

It seems to me that Jim's paintings fall into two categories. The first are mighty vistas of machine-filled futuristic or alien landscapes, immensely detailed re-inventions of *Metropolis* and the covers of the pulp magazines of proto-modern SF, thrumming with energy, and looking as if everything in them actually works. The second are anchored by the novel's protagonist, a fiercely exotic person (often a young woman with a pure Pre-Raphaelite quality) gazing out at some wonder the viewer isn't privileged to see.

I've been lucky enough to have been gifted with both types of paintings as covers for my novels.

That of *Red Dust*, a picaresque set on a Mars half-terraformed by the Chinese, is full of war machines: the exotic fliers, like hunting wasps; the soldiers enveloped in their armour; the soldier's mounts, fearsome sabre-toothed warhorses enveloped in high-tech carapaces. Jim has taken the bones of a brief scene and invested it with details from elsewhere in the novel, all deeply infused with his own imagination. The cover makes no overt references to Mars, but with the hard pink sky and litter of red rocks half-buried in red sand, it's a quintessential Martian landscape. The organic shape of the fliers complements the coralline detailing of the warhorses' carapaces; the articulation of the fliers' wings is so realistic you could go out and build a working model. It won a British Science Fiction Award. A photographic reproduction hangs over my desk, goading me to keep trying to get that kind of imaginative response to my prose.

There are machines in the painting for the cover of *Pasquale's Angel*, too. Appropriately enough in a sixteenth-century Florence filled with the fruits of the imagination of the Great Engineer, Leonardo da Vinci. That peasant seems about to lose control of his big steam wagon; the driver of the other steam wagon (on the back of the wrap-around cover) has sensibly pulled over to let him past. The wagons, the barge and the lifting screw across the river have a wonderful hand-crafted look, and could have stepped straight out of Leonardo's notebooks. But what holds our attention is the figure in the foreground, Pasquale in his very best clothes, looking thoughtful and a touch apprehensive as he lets loose the little model flying machine on which the plot turns. Authors are often wary of depictions of their characters on the covers of their books; it violates an implicit trust between author and reader. But Jim's careful and sympathetic reading of the text and painterly skill have captured Pasquale so faithfully that I wish I'd had the picture pinned over my desk when I was writing the book.

PASQUALE'S ANGEL
(*Gollancz*)

One of those alternative histories which John Clute neatly categorized in his Interzone review of it as 'Carnival Steampunk', *Pasquale's Angel* was further evidence to me at the time that in Paul McAuley we have in the UK one of the most interesting and singular writers working in the genre. I'd already painted the cover for *Red Dust* – a book which I found wonderfully readable – but *Pasquale's Angel* proved to be an even more involving piece of truly imaginative fiction. People often ask me (yes, they really do!): – 'Where do you get your ideas from?' It's a question which, for a narrative illustrator like myself is easily answered – 'why, from the words of the writers whose books I'm illustrating, of course', comes the somewhat prosaic, but ultimately truthful answer. OK, I lay on my own diseased vision, my own organic encrustations, etc. I am, I suppose a kind of purveyor of exotic patinas, many and varied, to visions already substantially made real by the writers' words. It's in the surfaces that my ideas largely find expression. Much more interesting is the question: 'where do writers get their ideas from?'. It's the quality of that leap of the imagination, that 'what if?' question that has convinced me many times that I could never begin to hack it as a writer. I just don't have the ideas! So, what if Leonardo da Vinci said, 'To hell with this painting malarkey', and concentrated instead on his engineering and inventing skills? OK – no *Mona Lisa*, no *Madonna of the Rocks*, no *Last Supper*. Instead, the Industrial Revolution happens in early 16th-century Florence and not in 19th-century England. History lurches off at a bizarre tangent and everything follows from that clever premise including my attempt to do some sort of justice to a very original idea. I used some of Leonardo da Vinci's own drawings to recreate the river-dredging machines and the famous proto-helicopter we see here ascending in model form from Pasquale de Fiesole's hands. The steam-driven cars are loosely based on a variety of 19th-century designs whilst the stencilled inscription on the side of the left-hand vehicle, 'CAVOLO/CAVOLFIORE/ PISELLI' ('cabbages/cauliflowers/peas') is there courtesy of the Sainsburys' *Book of Italian Cooking* from which I shamelessly extracted the translations.

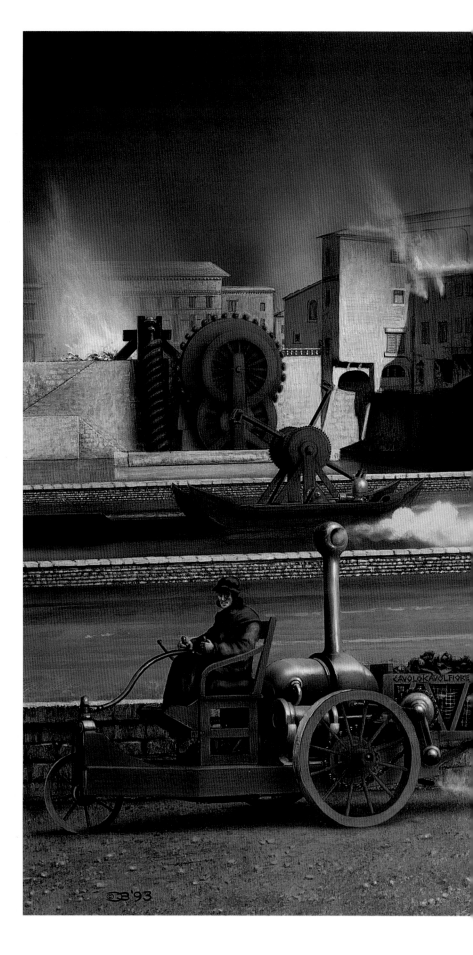

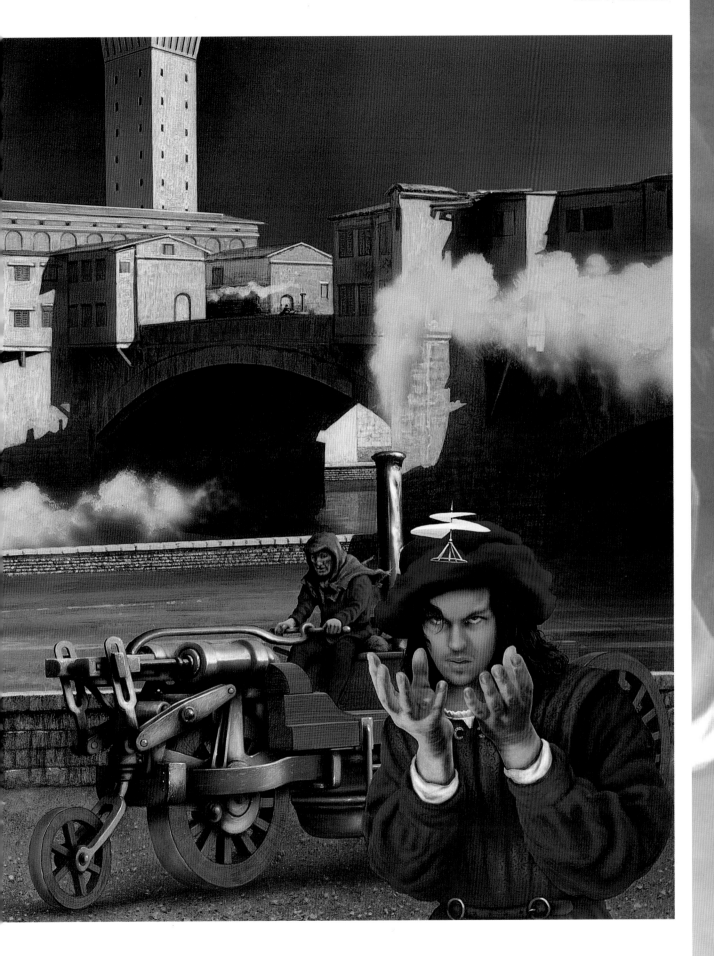

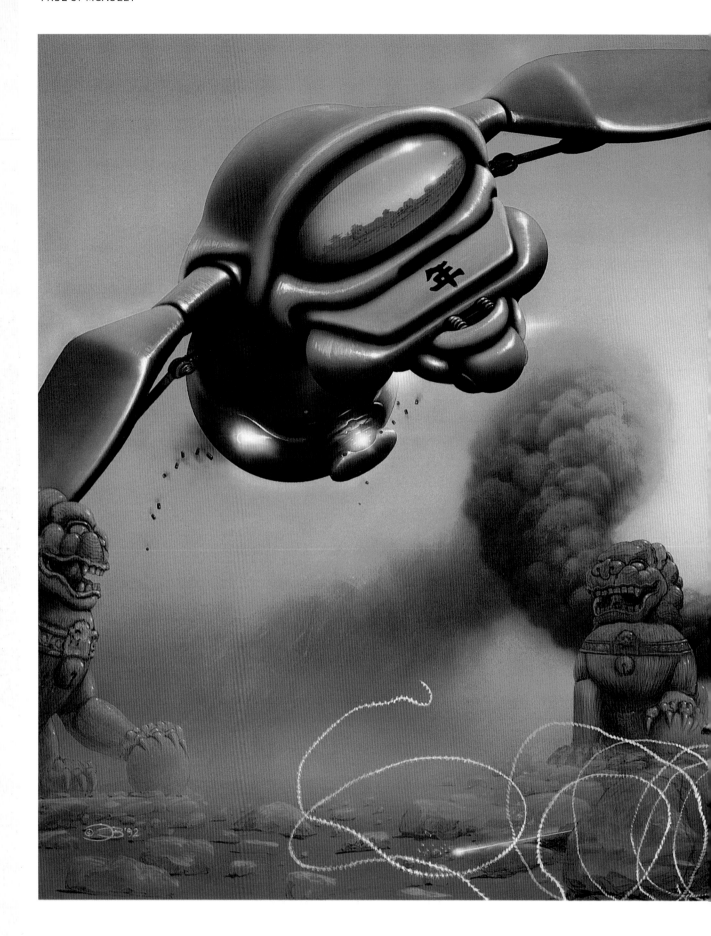

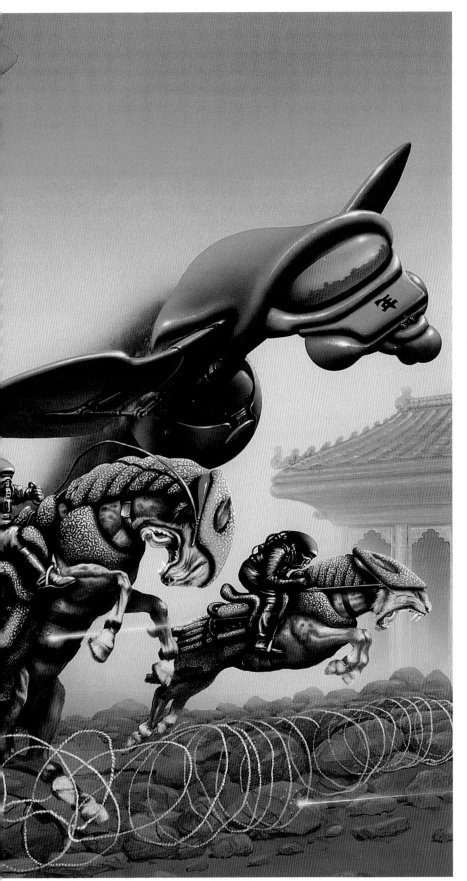

RED DUST
(*Gollancz*)

What an astonishingly inventive writer Paul McAuley is! He seems to me to bring together a pretty unique combination of a very deep knowledge of the genre, a healthy injection of wit and an almost manic energy which keeps his plots absolutely galloping along. With his own scientific background the science in his books carries real conviction.

A whole bunch of books emerged back in the early/mid 90s with the planet Mars as the great central idea. *Red Dust* was probably the most original of them all. Five hundred years into the future, Mars is a sort of Chinese-run wild-west frontier planet. We follow the story of young Wei Lee and his adventures and travails across the planet – which are many and varied and truly bizarre (I loved the AI probe in orbit around Jupiter which takes on a sort of virtual Elvis Presley persona!).

When I set out to paint human-built flying machines (or any kind of hardware, really) it's always a case, theoretically anyway, of attempting to suggest that the design rationales behind them are different from those applied to last week's painting. So last week, depending on the book, I might have painted aircraft that have, say, the vague suggestion of US design-thinking fifty years down the line, or the products of some heavy-duty fascist regime of the future, or maybe a kind of ethereal, New Age style of machine – all of which is to say that I try not to repeat myself. So here we have Chinese-on-Mars fliers, which Paul rather oddly calls 'culvers' (apparently derived from the word 'culverin' – an antique species of long cannon or small firearm according to my dictionary). I've given them articulating wings and the suggestion of pseudo-insectile thoracic and abdominal fuselage sectioning – all rather arbitrary but, if executed with a degree of 'attention to detail', convincing. I don't think too deeply about this – it could become a bit obsessive – but an awareness of this kind of minutiae is what makes a picture work on levels beyond the immediate and obvious and stops every painting drifting towards a general similarity. Also – very important this – it keeps my own interest very much alive.

Reproduced here are the first four illustrations of the full series of six I completed for the Venus Prime stories. These books were written by Paul Preuss, but each of them uses as its core idea a short story or novella from the vast outpourings of Arthur C. Clarke. It's an unusual kind of collaboration to say the least, but the books are pacy and highly readable and it was amusing to re-read the Clarke stories in this revamped form. I did enjoy painting them very much, in particular the delightful Sparta, central character of the six novels. Sparta is a code-name (SPecified Aptitude Resource Training and Assessment) and she is no longer entirely human having been implanted with myriad devices to enhance her senses and capabilities. In effect, I suppose she is some variety of cyborg.

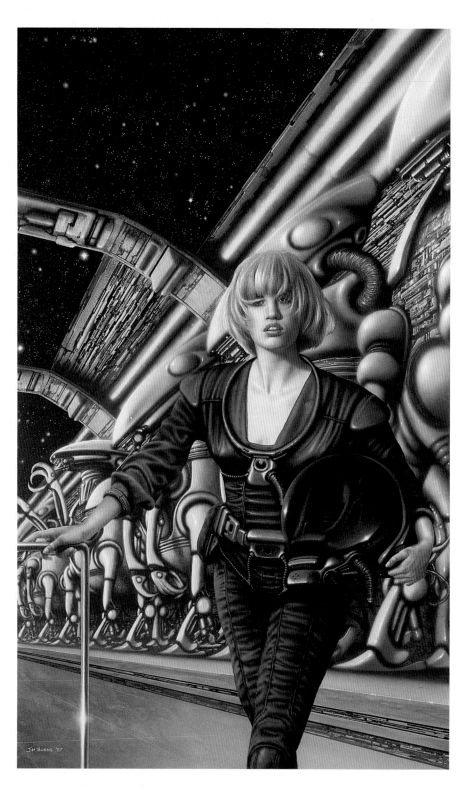

Right:
VENUS PRIME 1: BREAKING STRAIN
(*Avon*)

The original painting for this first book in the series was quite different. Underneath the blonde in the black spacesuit is a totally different girl in a different pose in a red spacesuit, helmeted up. The client didn't like her at all and I was obliged to completely repaint her. I have to admit, she did look better second time around though. I got my wife to pose for the body reference. In the photographs she carries a large casserole pot doubling as a helmet. (Merely to get the arm and hand angles right!) In my painting, she is taking a look around one of the spooky holds in the interplanetary ship, the 'Star Queen', in which are stored the large mining robots bound for Venus.

Opposite page:
VENUS PRIME 2: MAELSTROM
(*Avon*)

My personal favourite of the six paintings. With all those wonderful photographs taken on the Moon's surface by the Apollo astronauts, there's no excuse for not getting it right any more. Nowadays I would have a bit more courage about putting convincing reflections across the transparent bubble of the moon crawler she's sitting in. Back then I was fearful of obliterating some of that nice red interior

I'd created. Sparta has changed from a black suit to a white one. In fact, she wears a different-coloured suit for each cover, most of them fairly revealing. When I completed the full-size pencil sketch for this one I decided to try and be a bit more mature and give her a much more slender, less voluptuous figure and to cover the resulting, more modestly endowed figure with a suit velcroed up to her neckline. Back from the client

came a couple of suggested alterations (actually demanded rather than suggested). 'Kindly give Sparta a more generous figure and a much more revealing neckline. This spacesuit does not do her justice. And make her lips sexy'. But I do try, honest I do (for those of you out there who still insist on regarding me as an MCP of the worst sort who likes nothing better than to shamelessly exploit the more pneumatic attributes of the female form).

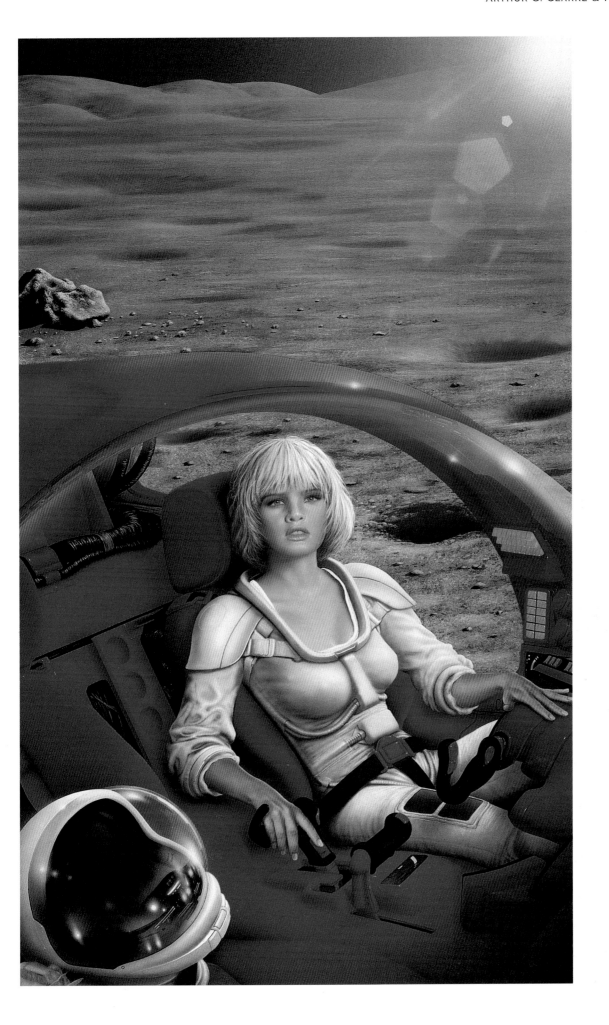

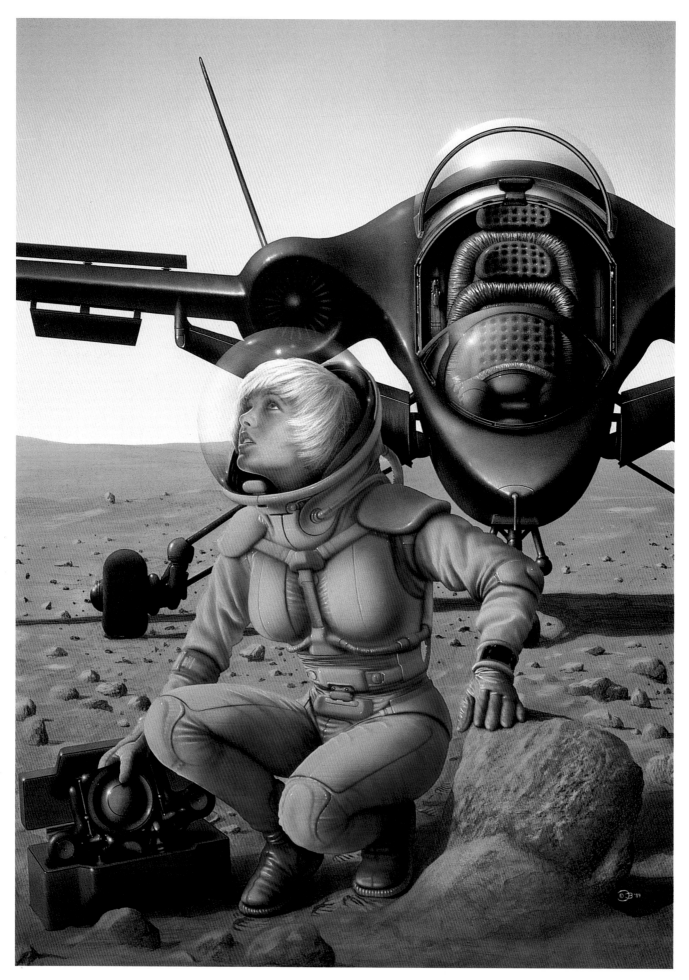

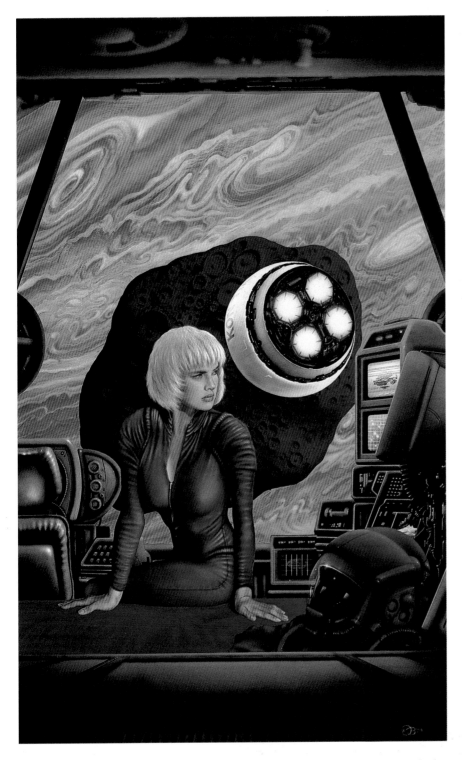

Left:
VENUS PRIME 4:
THE MEDUSA ENCOUNTER
(*Avon*)

In this fourth book in the adventures of our technologically enhanced space heroine, the core tale from Arthur C. Clarke is the famous 'A Meeting with Medusa'. Consequently, the locale for the painting is Jupiter – and again I've dipped into the old archives to scrutinize the Voyager shots of the gas giant, for accuracy's sake. As you can tell, after my experience with Book 2, I've given up on any attempt at moderating Sparta's curves. If anything, she's acquired even more curviness as the series has gone on.

Opposite page:
VENUS PRIME 3:
HIDE & SEEK
(*Avon*)

Sue again posed for the body position of this cover. I've got dozens of daft photographs taken over the years of Sue doing her model bit. The best ones from this session are the cruel final shots gratuitously taken as she attempted to stand and fell over, her legs having gone to sleep. The one that gave us the biggest laugh of all (by 'us' I, of course, mean 'me') is where she is sitting on a chair with a bed sheet draped around her looking wistful and preoccupied whilst fiddling about with a wire coat hanger. In the painting (for the novel *Burning Sappho*) she becomes mysteriously transmogrified into the poetess of that name sitting in a boat in classical Greek-style robes playing a small harp. I must say the wonderful photographs sent back by the various exploratory space probes over the years have helped to concentrate the mind wonderfully when it comes to painting realistic planetary vistas. It's easy to see the influence of the two US Viking Mars landers in this illustration.

IAN McDONALD

Arsy-versy. Fiction doesn't always inspire art. Art – Jim's art – inspires my fiction. His vision of a messy, vaguely biological, sexy future inhabited by people who looked as if they lived there, rather than on tour from Hackensack, shaped my private future-verse. I wanted to write like he drew. I wanted spaceships that looked grown rather than riveted; I wanted dangerously sexy aliens; I wanted other worlds that looked as if they smelled of God's pheromones. Organic, cute, steamy.

And Lo . . . The runaway biotech of *Hearts, Hands. . .*, is pure JB, I confess, as is the nanotechnologically immortal, infinitely mutable and resurrectable society of *Solomon Gursky*. And he probably doesn't even know it. But what I admire most is that Jim's got the gonads to admit that, hey! the future may be all these great things, but also, black.

Dangerous visions . . .

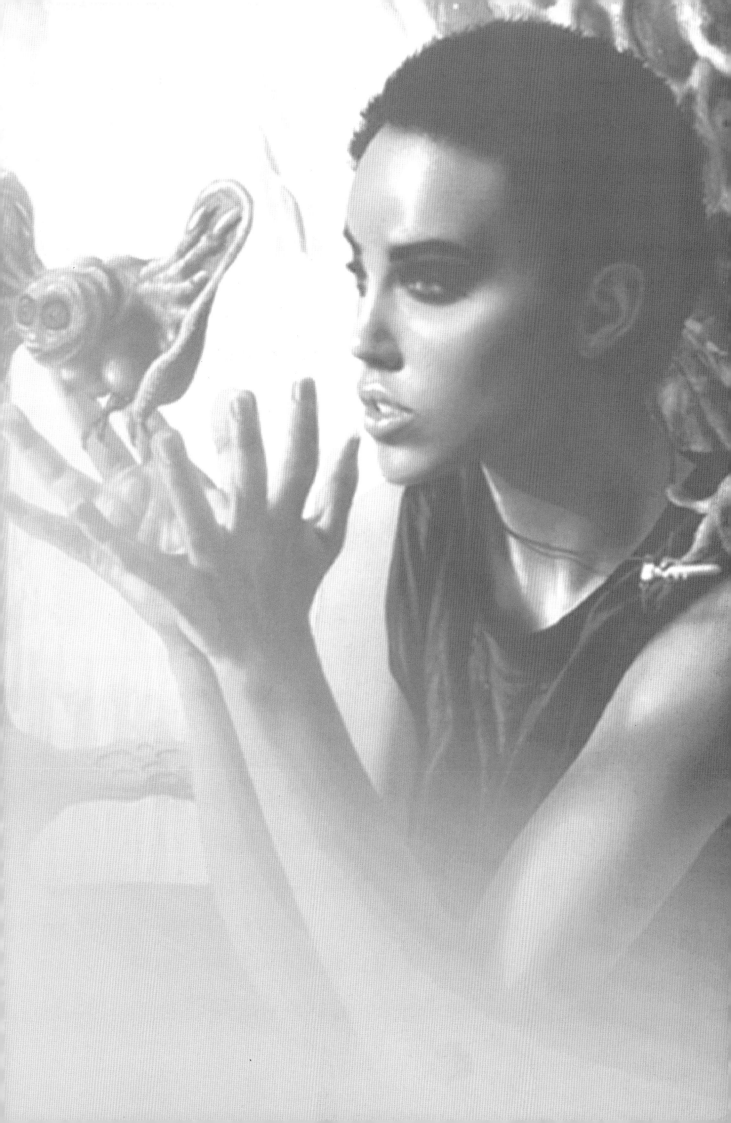

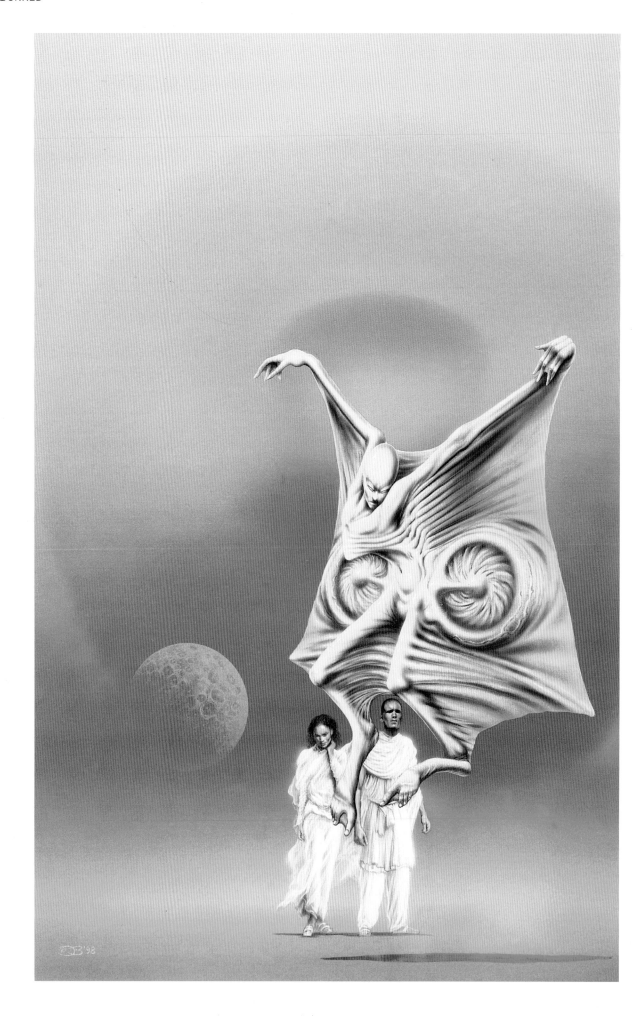

Opposite page:
THE DAYS OF SOLOMON GURSKY
(*Asimov's Science Fiction*)

It seems that evolution has some pretty weird cards left to play, if the remote future is anything like the one that Ian McDonald presents to us in this excellent and truly off-the-wall short story. The end-time he conjures up is as bizarre as anything I've read and put me in mind, I think (for it's decades since I read it), of Olaf Stapledon's *Last and First Men* – at least in its exploration of the possible evolutionary directions our human form might take. Ian's flying man with the naturally evolved propulsion fans in the membranes linking his arms and legs is a gift to the artist – though not necessarily the obvious choice as just about every page of this and every other Ian McDonald story I have ever read is peppered with outrageous descriptions begging to be illustrated.

Unfortunately this and the illustration for *The Children Star* came to a sticky end somewhere in New York not so long ago in the hands of a caring local courier service. I haven't suffered too badly from damaged artwork over the years, but to lose two paintings in one go seems a bit unfortunate, to say the least.

Above and overleaf:
HEARTS, HANDS AND VOICES
(*Gollancz*)

There is something uniquely satisfying about Ian McDonald's writing. There's a richness of prose and a textural density rarely matched in SF, in which it's sometimes a little too easy to get lost, particularly if one is reading it as I do with a view to extracting visual motifs rather than just for its literary possibilities. I'm always amazed that Ian manages so neatly to bring everything to a satisfying conclusion, given the complex weaving of his narrative! He is a true juggler/conjurer of the genre.

The wonderfully allegorical tale of Mathembe Fileli in *Hearts, Hands and Voices* was such a joy to illustrate. Its haunting impact stayed with me right through the painting process and as a consequence, I think I produced one of my better efforts. You really care about the characters in an Ian McDonald novel, a thing not commonly experienced (for me anyway) within the genre.

I fused the head of one model (in paint that is!) onto the body of my eldest daughter Elinor, then in her early teens, for the character Mathembe. The model for the head was white-skinned and fair-haired but acquired a more ethnic complexion and hair style and colouring as demanded by the text. Apart from that, the rest of the picture is pure invention, a kind of painted free-association exercise pretty much divorced from the original sketch – the intention being to try to impart a sense of a future driven by the largely unchecked forces of bio-technological advance. I particularly enjoyed trying to convey in the design of the helicopter-like aircraft a kind of insect/machine hybrid by means of the rotating, searching beetle-like head/cockpits.

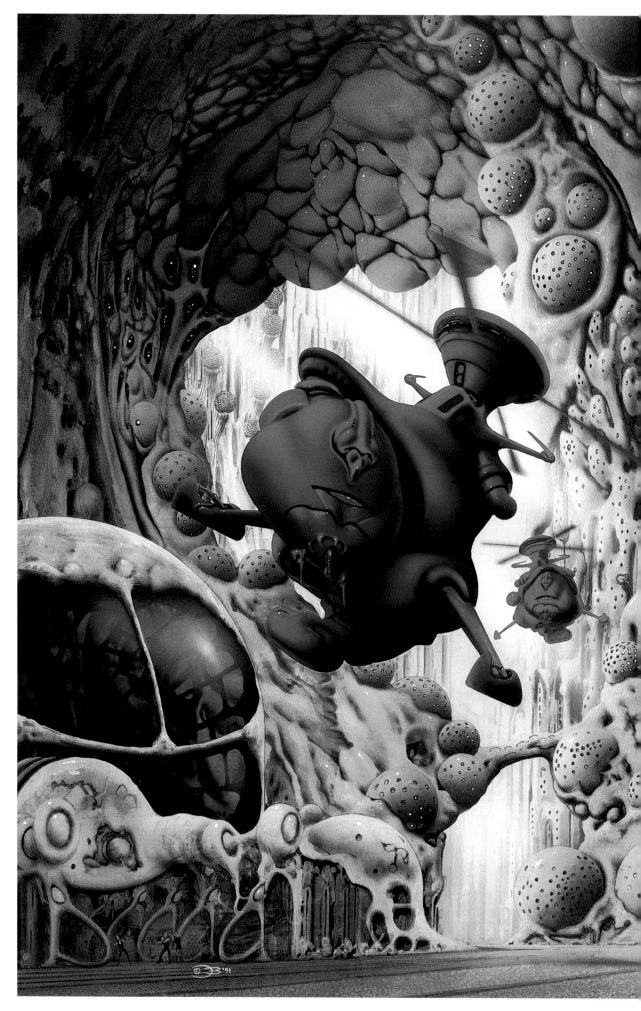

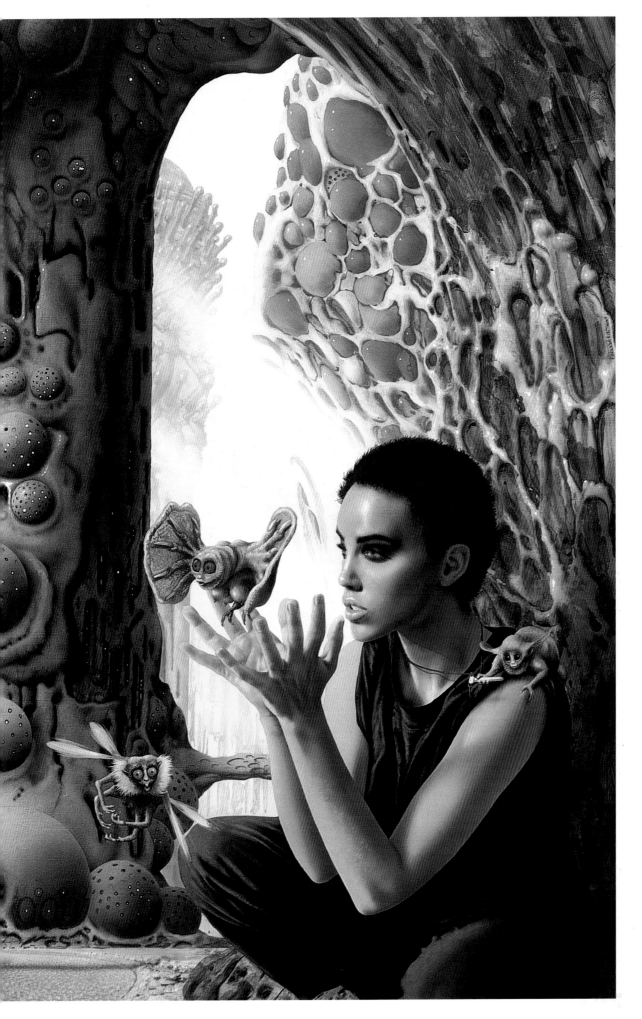

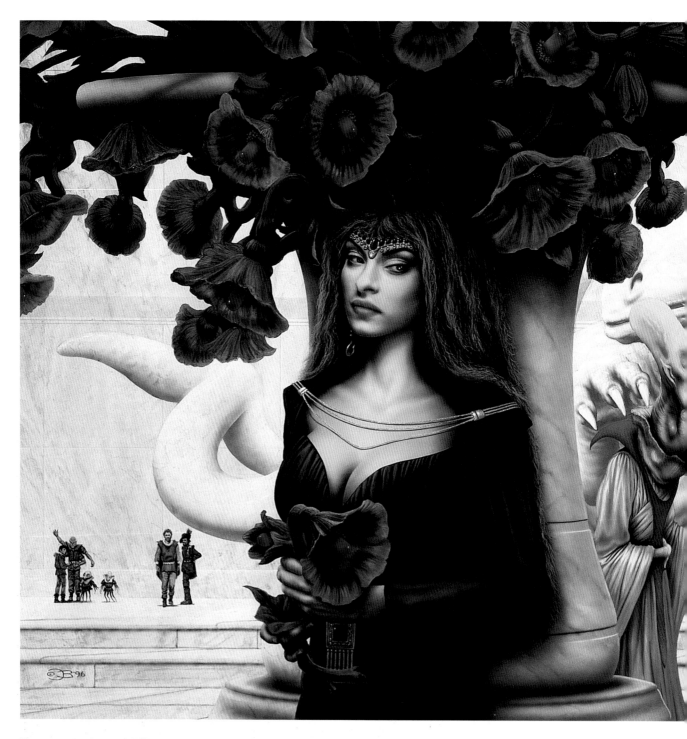

SORCERERS OF MAJIPOOR

Robert Silverberg
(*Macmillan*)

I've painted more covers for Robert Silverberg's books than anyone else – by a very long margin. Nine covers for the Majipoor saga alone. Each time a new one comes along a little *frisson* of pleasurable anticipation attaches to the job because I know that I'm going to be on a peculiarly empathic wavelength with Bob's text. No one conjures up vast, exotic otherworldly sagas of truly epic grandeur better than Bob (OK – some may argue the case for Jack Vance!).

It's almost 20 years since I completed the cover illustration for *Lord Valentine's Castle*, the first volume in the vast *Majipoor* cycle. And still the tale unfolds. The rich mix of characters, exotic settings and wondrous strangeness is still all there, a huge reservoir of material from which to extract ideas for a cover painting. Except that this time I didn't get to read the book before attempting the painting! This seems to be a growing trend in publishing on both sides of the Atlantic. The scheduling is such that less and less often is the manuscript finally delivered before work has to be commenced on the packaging. This is *not a good thing*! Whilst one can work with a summary of the plot and brief character descriptions, what's missing is ambience. The quality that stops every painting looking like every other painting. I have to immerse myself in the texture of the thing in order to do it real justice. In the event I seemed, more by accident than design, to get this one about right (according to Bob anyway). I don't know how charmed and distracted Bob might have been though by the cheap but effective ploy of including the bosomy form of the Lady Thismet on the back cover (perhaps confused by the pictorial revelation of her fairness when her physical description in the book suggests a dark sultriness – a further consequence of insufficient information). My wife, Sue,

Below:

LORD PRESTIMION (detail)
Robert Silverberg
(*HarperCollins*)

This was the first time I was given the go-ahead by a client to produce a book jacket illustration in a digitally realized form on my computer. No painting exists for this image. It's just a bunch of electronic data on my hard disc. Many commercial artists have yet to be convinced of the capabilities of these machines. For some of them the sensual and olfactory pleasures of paint itself is enough to keep them firmly rooted in tradition. Some see the computer almost as a near-demonic incarnation which will mean the death of painting. Which is nonsense. It plays a not dissimilar role, albeit a more profoundly revolutionary one, to the airbrush thirty years ago, certainly in our strange little world of science fiction art. Which is to say that a desirable new tool has entered our studios

and all is now changed as a consequence. Since I bought the computer a couple of years ago I haven't stopped painting and neither will I.

Lord Prestimion is the most recent novel in the wondrous *Majipoor* cycle and the tale that unfolds takes place immediately after the end of *Sorcerors of Majipoor* – a thousand years before *Lord Valentine's Castle*. Bob provided a brief summary of the tale and it had been pretty much decided anyway to feature the Isle of Sleep on the cover – for which there was plenty of reference in earlier Majipoor volumes. I had enormous pleasure creating the exotic wooden sailing vessel shown in this detail. Pushing the details around in Photoshop with my graphics tablet and stylus was an absolute revelation.

I was immensely flattered and rather touched to discover that Bob Silverberg had dedicated *Lord Prestimion* to me. I value the very positive relationships I've built up with many writers over the years – but the one with Bob is very special.

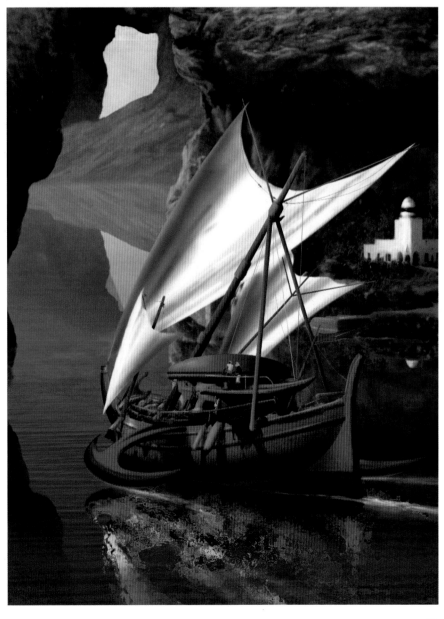

had recently bought me a beautiful book of paintings by the Dutch-born Victorian artist Lawrence Alma-Tadema – the man who more than anyone else defined forever our (and particularly Hollywood's) vision of ancient Greece and Rome. No one does marble like Alma-Tadema. Consequently I was in a very 'marble-conscious' frame of mind and this fed seamlessly across to this painting.

Of course, some people complain about the pulchritudinous overstatement of Thismet's breasts. All I can say is – read the book to find out how honest I'm being to Robert Silverberg's text! (Though I can't pretend to struggle too hard with my conscience over this non-problem).

STAR OF GYPSIES
Robert Silverberg
(*Questar*)

A picture from the late 1980s when it seemed that every other painting I produced was for a Robert Silverberg book. I've painted well over thirty separate Silverberg covers – far more than for any other single writer. They are always a pleasurable challenge, this one included. This was a swashbuckling and picaresque tale in which I tried very hard to capture the physical qualities as I saw them of Yakoub '. . . an ageless rogue carousing through a galaxy of endless wonder' as the cover blurb put it. He is 'a lord, slave, hero, beggar, lover, thief, survivor, ghost'. A pretty well-rounded character, then! In the dramatic sky is the legendary home of Yakoub's people – the Star of Gypsies itself. The appearance of the star here is modelled somewhat on Skylab photographs of our own sun taken back in the 1970s. Every science fiction artist should equip him or herself with a good library of reference material if they wish their paintings to carry the ring of conviction.

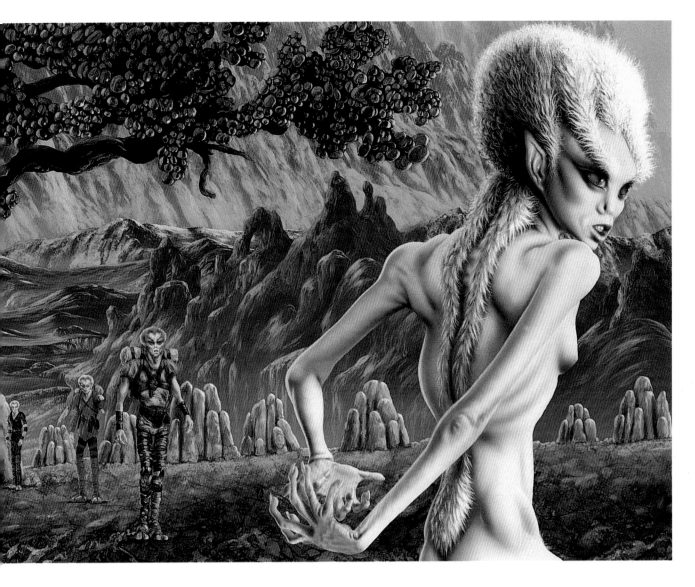

KINGDOMS OF THE WALL
Robert Silverberg
(*HarperCollins*)

The chief protagonist of *Kingdoms of the Wall* is probably Kosa Saag, the immense, unclimbable mountain (the 'wall' of the title). The mountain and the increasingly strange communities encountered by an intrepid band of Human-ish beings led by one Poilar Crookleg is a wonderful creation of a variety that Robert Silverberg undoubtedly does better than anyone else.

My poor long-suffering wife, Sue, who in her capacity as unpaid model has gamely taken on the roles of space-heroines, scantily clad floozies and victims, Sappho the Greek poetess and the Bride of Frankenstein amongst others, posed for the rather weird alien girl on the far right of the composition.

I only used her arms and hands in the end and largely invented the head and body – though it shouldn't be deduced from this that Sue has six fingers on each hand. A lot of photo-reference material is simply a starting point from which flights of the imagination are launched.

Apart from those hands, everything else in the painting was pretty much made up as I went along – revealing a self-confidence this time around that I assure you is not always there.

THE FACE OF THE WATERS
Robert Silverberg
(*HarperCollins*)

Half a millennium into the future and
Humankind is scattered throughout the
cosmos, the Earth itself destroyed two
centuries earlier. On the water-planet
Hydros we are once again on one of
those singular Silverberg worlds where
men pit themselves against the almost
overwhelming physicality of the place.
With Robert Silverberg it's often a vast
mountain, but this time it is a world-
encompassing ocean with a sprinkling
of islands. Humans are trapped on this
forbidding world by the unbending dictat
of the dominant indigenous species, and
our particular little band of humans
spend the larger part of the novel
wandering the unfriendly oceans of
Hydros. It is, like so much of Robert
Silverberg's work, a rich and heady mix
from which to draw one's cover material.

I absolutely love creating these ships
that have something of the carrack or
the ketch or the galleasse about them,
combined with the suggestion of the
faintly arcane and half-lost technologies
of the times yet to come. It may be a
Silverberg fiction of the far-flung future,
but it doesn't hurt at all to have boned
up a bit on Joseph Conrad – simply to
amplify that sense of nautical romance
which would seem to be appropriate to a
book like this. I want the viewer of this
painting to hear the creaking of yardarms
and the cracking of canvas! Again I
became over-obsessed with detail. If you
look very, very closely at the transom end
of the vessel, through the two windows
into the cabin, you will see a man and a
woman – two of the chief characters –
plus map tables with maps on and other
sundry detail – all great fun to paint,
but largely irrelevant in respect of the
painting's function as a book jacket.
The size of the reproduced image
combined with the often so-so quality of
the printing mean that such details are
completely lost!

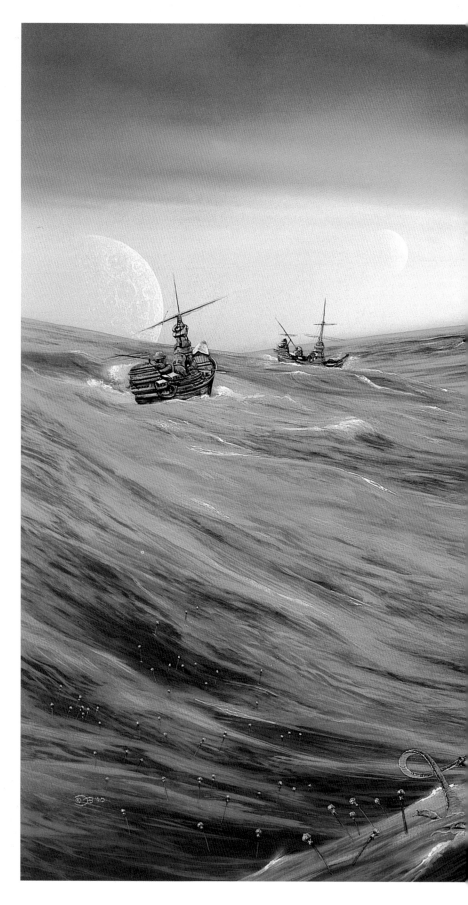

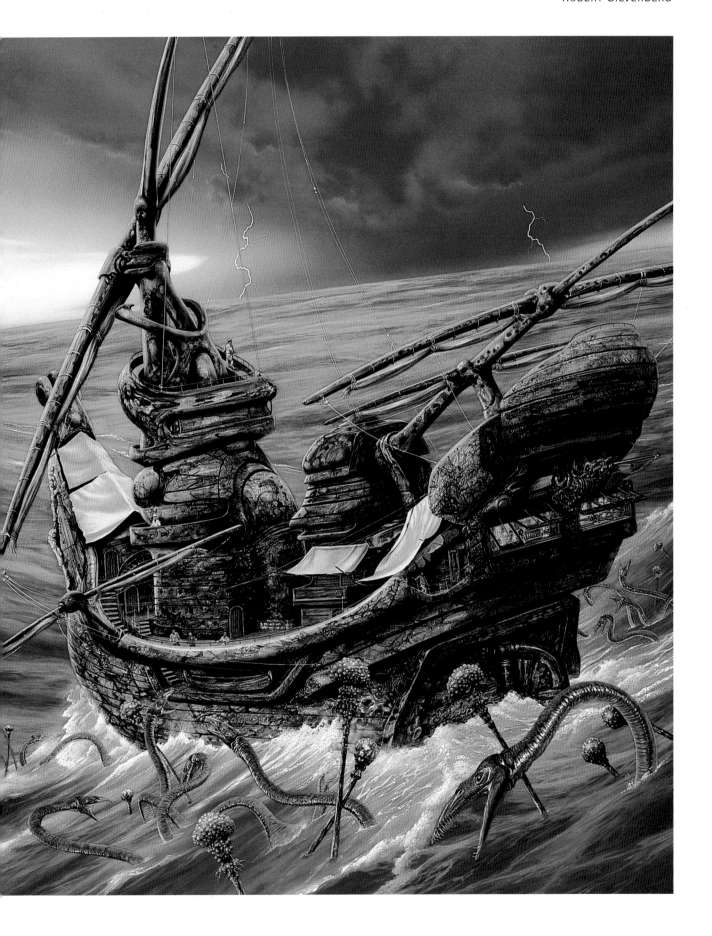

Opposite page:

A Song of Ice & Fire
1 : A Game of Thrones

Above:

A Song of Ice & Fire
2 : A Clash of Kings

George R. R. Martin
(*HarperCollins*)

These were the books that brought George R. R. Martin back to fantasy fiction after a decade away working in film and television; the first two volumes of, I believe, a four book series – and a very superior style of fantasy it is! A bleak and tragic vision, it has something of the historical romance about it, being full of court intrigue, quasi-Arthurian knights in armour and much sword-wielding violence. On top of that there is the promise of a more magical style of fantasy in the background, including that most tried and tested symbol of the genre – dragons! I refer to these dragons in the framing device of the two black, horned skulls in *A Game of Thrones* and again in the two mirror-image wyverns of *A Clash of Kings*. All the various elements that make up these images refer directly to sections of the narrative and characters that appear. Those readers who have perhaps read Book 1 will note that the small framed character profile, bottom right, is different from the published version. The art director took against this original version and asked me to replace it with a different character altogether. The particular varnish I'd used didn't

allow for acrylic overpainting and the new version was painted as a separate little insert which was scanned and inserted digitally. The series of paintings are supposed to suggest in their colour schemes the passage of the seasons – so Book 1 should convey a 'summery' ambience whilst Book 2 is intended to have something 'autumnal' about it. Books 3 and 4 will be – predictably – wintry and springlike.

When Malcolm Edwards, then at HarperCollins, first spoke to me about these commissions, he suggested the tried and tested fantasy approach of highly decorative, densely illustrated covers utilizing intricate framing devices to enrich the whole effect. I'd been paying visits to a local timber merchant, hauling off bog-standard 2 x 4 for some mundane domestic reason or another but had been much distracted by the wonderful selection of exotic wood veneers in the 'skilled craftsmen' corner of the shop. I couldn't stop fingering these beautiful, wafer-thin sheets which seemed to contain within the tortured, highly figured burr grain an infinitude of organic possibilities. I decided that the varnished surfaces of a variety of these veneers – a different exotic wood for each cover (this is probably all very ecologically unsound, but I only used really tiny amounts – honest!), would make perfect backgrounds for the illustrations and so, having had the sketches approved, made the (rather expensive) purchases. I'd not really anticipated the problems that then ensued. For some reason it hadn't occurred to me

that any particular skill was required in the handling of veneers. By the time I'd finished lightly soaking the sheets, applying the adhesive film to the back, ironed the veneer into place, pulled it all off because it had split badly, contracting under the heat of the iron, replaced the veneers, cut the complex shape with a scalpel, sanded down to a smooth finish, replaced the whole lot again when I sanded right through to the gessoed board beneath – I was climbing the wall with frustration. I guess the final thing looks OK – but the veneer work really doesn't stand up to very close scrutiny. The second cover was marginally easier as I was more aware of the pitfalls – but this is definitely work for someone with skill and experience. Someone, who shall remain nameless, suggested I put some toughened glass over the paintings, screw a leg into each corner and flog 'em as coffee tables –

a little hurtful after all the hard work (but I can see her point). I can't say I'm desperately looking forward to the veneering of Books 3 and 4, but it's another case of 'I've started so I shall finish'. Notwithstanding all that, I was pleased with the final results and I have both paintings hanging on my studio wall at home. They seem popular at conventions with lots of little details to peer at between the tormented shapes of the veneer decoration. Sadly, people rarely comment on these veneers and I was particularly put out when someone – a fellow professional artist – asked me from which kitchen unit supplier I got hold of the interesting plastic laminates.

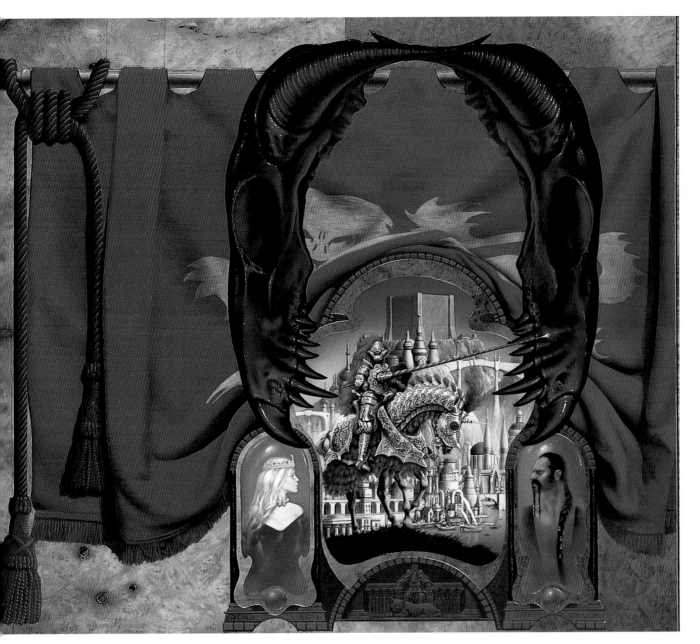

Right:

THE BOOK OF MANA
1: LUCKY'S HARVEST

Opposite page:
THE BOOK OF MANA
2: THE FALLEN MOON

Ian Watson
(*Gollancz*)

The Book of Mana is essentially a science fiction re-telling of the Finnish heroic epic poem the *Kalevala*. In Finno-Ugric mythology the land of Mana or Manala is the name attached to the Finnish underworld. It shows Ian Watson at his most brilliantly inventive. He brings an extremely formidable, but playful intellect to his writing which gives it a flavour completely unique in the field.

In both illustrations I created a four-panel design which dips into some of the principle elements from the story, the resulting combination hopefully giving something of the flavour of the book. On the right of *Lucky's Harvest* we have the beautiful, but one-eyed Eyeno, a principal character from the complex plot, whilst in the central panel I've painted a Juttahat (the human-like being with the leaking chin glands) and one of the serpent-like Isi. A repellent master/slave relationship exists between the two species, the Isi being most emphatically the masters.

In *The Fallen Moon* I've used the same four-panel approach with variations to the actual shapes of the panels. The female on the left is the girlem, Goldie – actually a Juttahat modified in the image of a human and designed, if I remember correctly, to drive men mad with erotic desire. She was amusing to paint! The weird little fellow to the right is a robot. He is meant to be both ludicrous and rather scary. In the main panel one of the giant 'Cuckoos' as they are called carries off another of the story's chief protagonists. Look closely and you will see at the centre bottom of both pictures a small circular motif. These are derived from Lapp shaman drum designs, the one on *Lucky's Harvest* being a representation of the sky god, Ukko, whilst the design on *The Fallen Moon* is of Rauni, Ukka's wife. This is pretty esoteric territory really and nothing at all to do with the novels. I was simply making a kind of connection back to the Finno-Ugric origins. During a delightful convention in Jersey a few years back, and thinking I'd trip Ian up on this (there's not much he doesn't know!), I asked him if he had any idea what these little symbols were. He said he needed to cogitate for a moment and disappeared. When he came back to the

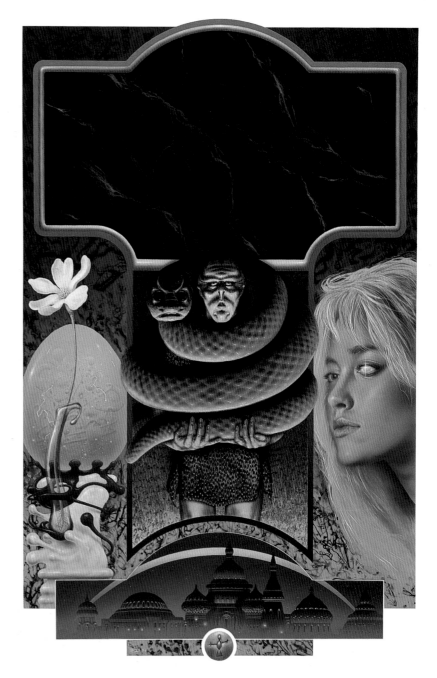

bar shortly after he said, 'Been thinking about those designs, Jim. They are Lapp shaman drum designs, that one is Mader-Atcha the sky-god, also known as Ukka, whilst that one is Mader Akka, wife of Ukka and also known as Rauni'. I was mighty impressed with this amazing show of Ian's knowledge of truly obscure stuff and remained so until another convention when he owned up to having slipped round a corner at the Jersey convention to consult one of the foreign visitors to the convention – a Finnish writer who was an expert on the iconography of Finnish shamanism.

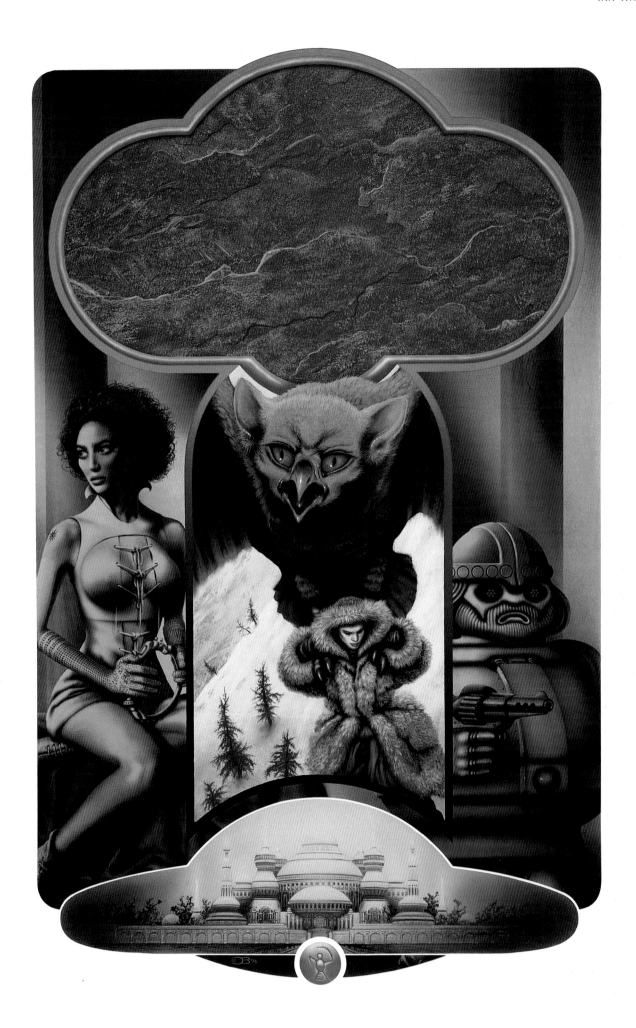

GREG BEAR

One of the marvels of publishing a book is getting to work with truly exceptional and visionary artists. Jim Burns is one of the best. When I received my copy of the UK hardcover of *EON*, published by Gollancz, I was astonished. Jim had captured the essence of my strange artificial universe, the Way, without once consulting me – and without using a computer to calculate the strange perspectives! The result is, I think, one of the most remarkable illustrations in SF . . . but of course, I'm prejudiced.

The cover for '/' (aka *Slant*, not 'Slash') involved a little more collaboration. Jim asked me to provide a sketch for the futuristic aircraft I described in the novel. I did so, and he turned it into a marvellous little cameo of aviation art. The rest of the cover is even more spectacular. He's captured the essence of Mary Choy neatly.

Jim's talent at catching both human characters and SF elements is unmatched in SF. I've visited David Brin's house many times, and the cover for *Startide Rising* is evocative and lovely.

Jim Burns reads our books, thinks about them, reacts to them, and makes art that reinforces and enhances the experience of the fiction printed on the pages. For writers and readers, who can ask for anything more?

Except, of course, more Jim Burns!

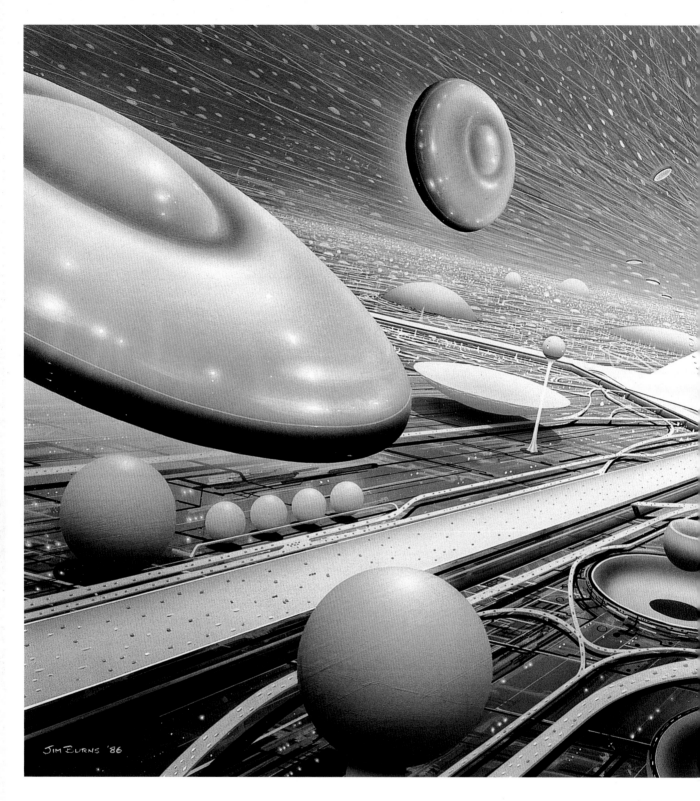

Jim Burns '86

EON

(Gollancz)

I've always loved Greg Bear's particular brand of hard, convincingly extrapolative science fiction. Every time I find myself immersed in one of Greg's books there's a point in the narrative at which I suddenly think, 'Yeah! – THIS is why I love science fiction!'

More than most writers, Greg takes a particular personal interest in the detail

accuracy of the cover art for his books. For me, this is never a problem – more a challenge to be met. Few writers of SF have Greg's amazing powers of description and he presents an artist with scenes of such epic grandeur.

I chose to go for a sort of macro-overview of the interior of the bizarre construct known as 'The Stone'. A place where physics takes on a new meaning. An exterior of plain, finite, asteroidal proportions housing a somewhat tweaked

interior of literally infinite dimensions, the super-science achievements of alternative-universe humans. ('The asteroid was longer on the inside than it was on the outside.' One of those simple, uncomplicated little asides that SF throws at you occasionally, which, in the context of the story, can send such a tingle down the spine!) I decided to try to convey a sense of scale and arcane geometries – humanity reduced to the microscopic entities presumably being transported in the ant-

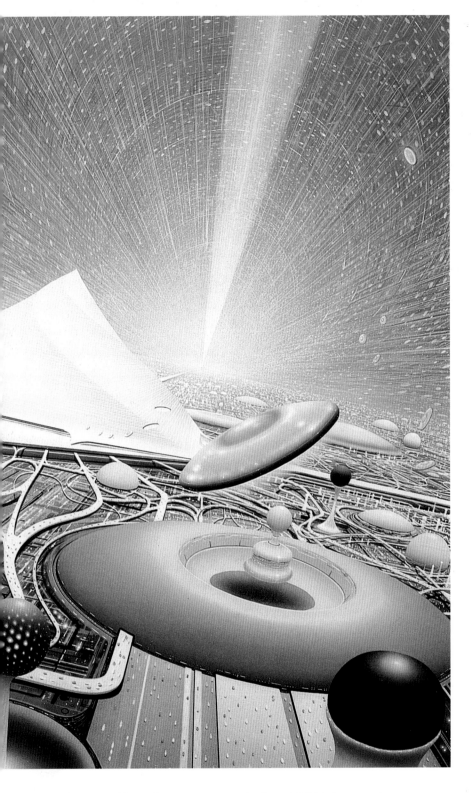

Overleaf:
SLANT
(*Tor*)

The nano-manipulated near future of
Greg Bear's *Slant* – and another pyramid!
This time round I decided to focus on
Public Defender Mary Choy, the central
character of this and an earlier book by
Greg, *Queen of Angels*. I spoke to Greg
on the phone during the early sketching
days of this piece, ostensibly to clarify
details of the evocatively named
'Swanjet', visible in the sky to the left of
the composition. At the time he was
understandably more interested in how I
was going to depict Mary Choy. It seems
that writers sometimes get very close to
their fictional creations and obviously
have a quite distinct mental picture of
them. Greg's image of Mary Choy struck
me as a little unusual, though. I think I
uncovered a long-standing crush on the
star of *From Here to Eternity*, as Greg
suggested I use Deborah Kerr as a model!
One of the more off-the-wall requests to
come my way and one which in the end
I'm afraid I pretty much ignored. I just
couldn't see Ms Kerr as some sort of
future cop! But I think Greg was happy
enough with the Mary Choy he got.

With regards to the Swanjet inquiry,
Greg faxed over a quick sketch of his
own to suggest the direction of his
thinking, and indeed the final version
in the painting quite closely follows
Greg's design.

like vehicles just visible on the
superhighways interlacing around and
along the Rama-with-knobs-on interior
of The Stone.

When I commenced painting the
white edifice at centre-right of the
composition I suddenly found myself
bamboozled by the actual geometries
suggested by its 'twisted pyramid'
description. I simply couldn't make the
thing look like any kind of coherent
architectural structure. In the event, I

built one! Which is to say, I cut a square
of card about 30 cm on a side followed by
a second square 29.75 cm on a side, then
a third, 29.5 cm, and so on, down to a tiny
last 5 mm square. I then glued the entire
stack together, each level twisted a
fraction around a vertical centre relative
to the one beneath. This wondrous creation
in cardboard and glue served admirably
as the model for Greg's rather more high-
tech version and – I can assure you – this
is what a twisted pyramid looks like!

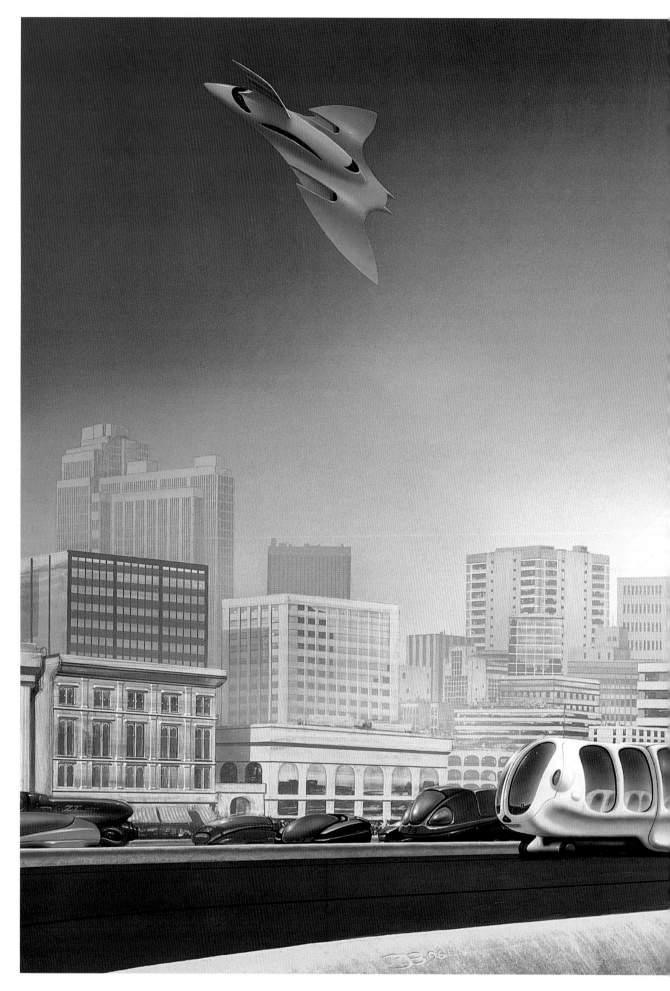

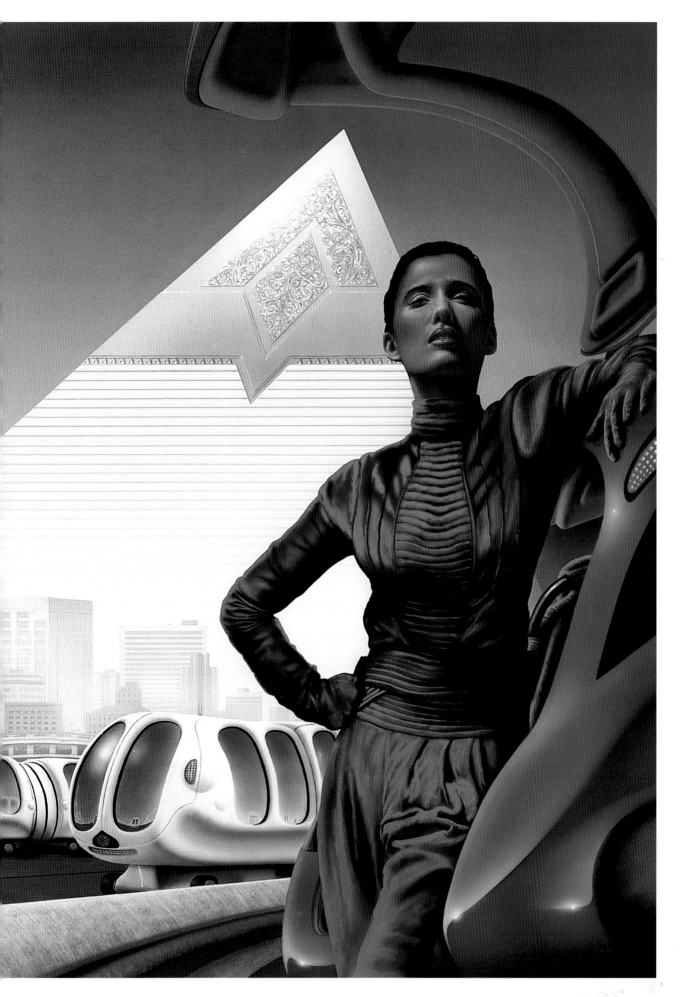

RESOURCES CENTRE

Right:
HOGFOOT RIGHT AND BIRD-HANDS

Gary Kilworth
(*Unwin Hyman*)

Actually the cover for a short story collection entitled *Other Edens* – an anthology of work by exclusively British-based writers. It was the first of three such collections, all of which I produced the covers for. These are marvellous tales by some of the best-known writers working within the genre. I was spoilt for choice when it came to producing a cover idea, but in the end I couldn't resist the offering from that absolute master of the short story form, Gary Kilworth. It is a real little gem and possibly the creepiest tale I've ever read! A future in which I certainly don't want to find myself living as an old person if my experience was to be anything remotely like that of the old woman in the tale. Her largely redundant body is fashioned by the caring 'welfare machine' into a variety of bizarre little pets with independent lives of their own and who inhabit her little apartment keeping her company. Hogfoot Right doesn't appear on the cover (but he can be seen on the T-shirt!). Neither does Basil or Snake-arm. Shy little Moth-ears makes it on to the back cover, but I decided to focus on Bird-hands for the front cover. Bird-hands is a most unsettling creation of Gary's and I hope I've done it some justice in this painting. My wife, Sue, posed for the hands. I was attempting to find that exact median point of ambiguity when the creature can flick seamlessly in the viewer's eye between its pair-of-hands origins and the bird-like form it is fashioned into by the welfare machine.

Below:
OTHER EDENS 3

Various
(*Unwin Hyman*)

Having completed the covers for the first two volumes in this short series of anthologies, along came the commission for Volume 3 (the cover for Volume 2 doesn't appear in this book). The big difference this time round was that at the time the job came up, none of the stories had actually been written! I was asked to create something 'appropriate' and 'in the style' of the preceding volumes, so I produced this metamorphosis idea which seemed to go down well enough. As a painting it's actually my personal favourite of the three.

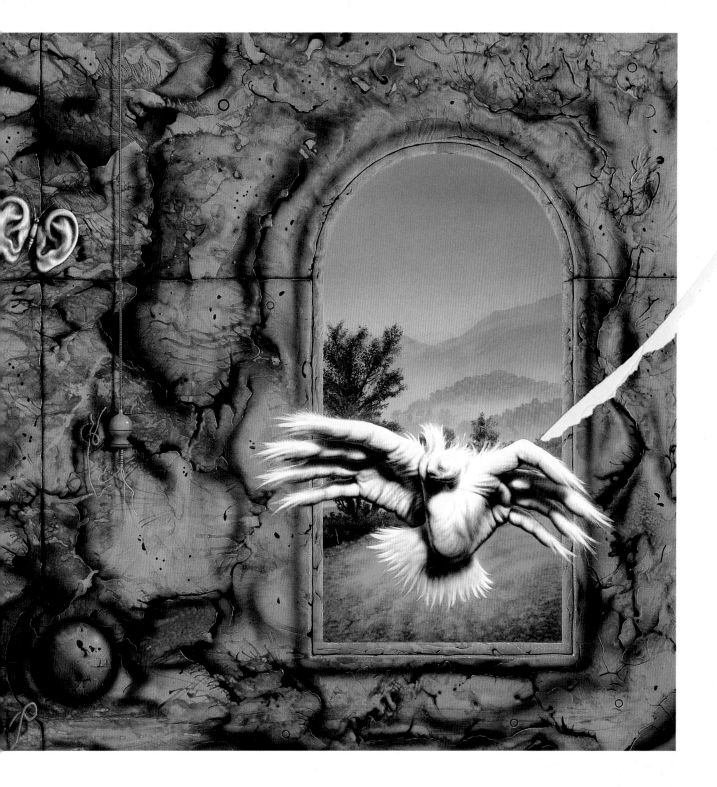

THE LONG RUN
Daniel Keyes Moran
(*Bantam*)

Vertigo-induced nausea was my aim here! A terrific passage in the story describes an aerial chase in which the classy flying cars of the future are involved in a queasy-making, corkscrewing pursuit up and around a vast skyscraper. I wonder if there will come a time when we will be able to trot along to our local Toyota/Ford/Renault showroom and order the latest model flying hatchback and simply take to the skies. The way a lot of people drive in the more familiar two-dimensional realm – I sure as hell hope not! Can you imagine the future equivalent of a motorway pile-up in fog with the addition of the vertical element thrown in? I don't want to be underneath when the skies start raining engine slag and body-parts! But the idea of the private flying car does persist. Maybe it will come about when the actual business of taking a vehicle from A to B is taken out of the hands of the car occupants and handed over to some kind of computer-

ized automatic control – a thing we'll be seeing in the quite near future on our current, stick-to-the-ground systems.

I got myself rather over-involved in one of those 'I've started so I shall finish' tasks here – namely the Painting of the Windows. Having painted in the upper few stories of the skyscraper's windows I felt obliged as I worked my way down to put in every window. As the rules of perspective took over I began to fear I was locked into a process akin to the 'frog on the table' phenomenon. A frog hops across a table. It gets exactly halfway across. It leaps again, but hopping- fatigue means it only gets halfway across the remaining half of the table. But after its first two hops it is three-quarters of the way across the table. Good going so far. Its third hop carries it 50 per cent across the remaining quarter, its fourth hop 50 per cent of the next bit and so on. How many hops does it take for the frog to get to the other side? The answer, of course, is that it never does make it to the other side as you can go on halving the remaining gap an infinite number of times.

SPACE MARINE
Game box lid
(*Games Workshop*)

At one time or another almost every science fiction writer and artist in the UK seems to have worked with the enthusiastic bunch of people who run the modern phenomenon called *Games Workshop*. Where I as a kid in the 1950s had my nose deep into the Eagle comic or making my Airfix kits (over 200 of those dangling from my bedroom ceiling at one point!), today's kids are reading *White Dwarf* magazine and assembling and painting Citadel Miniatures – both Games Workshop lines. As I write this, my 10-year-old son Joseph is sitting at his paint- and glue-encrusted table in the kitchen sticking together the parts of a Chaos Warriors chariot and painting it with a precision and attention to detail I find quite alarming in its intensity!

The best known of *Games Workshop's* creations is the world of *Warhammer 40K* and in particular the Space Marines – heavy duty warriors of a remote and intensely grim future which seems to hold immense charm for a whole generation of youngsters ('There is no time for Peace. No respite, no forgiveness. There is only WAR.' hmm.). I was asked to paint a box lid illustration for a Space Marine game and was drawn for a short

time into the arcane world of *Games Workshop*, paying several visits to the inner sanctum up in Nottingham where I discovered a dedication to their creations which was quite unnerving. The arcania of the *40K* world, its uniforms and armour, its banners and decorations, its weaponry are all very precisely delineated and essentially set in stone, leaving an illustrator with absolutely zero freedom to stretch a boundary or two. Which is a discipline if nothing else – allowing the imagination to concentrate on other aspects of the scene such as ambience and atmosphere, body poses and facial expressions. I was persuaded to paint the Space Marine chapter known as the 'Dark Angels'. It could have been the 'Ultra Marines' or the 'Space Wolves' or the 'Flesh Tearers' or the 'White Scars'. Many and scary are the chapters of the Adeptus Astartes!

I loved painting this violent and rather horrible picture. I got quite caught up in the accurate depiction of the detail work. Its grimness was entirely appropriate to the world of *Warhammer 40K*!

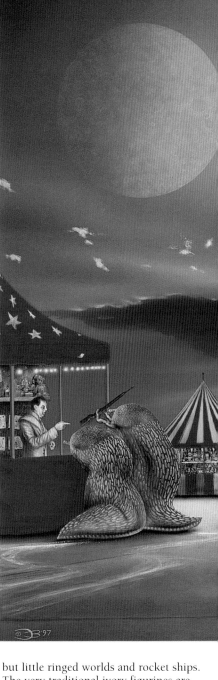

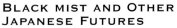

BLACK MIST AND OTHER JAPANESE FUTURES

Various
(*Daw*)

A collection of five novellas by Western writers, but all revolving around a Japanese-themed future plot of some sort. The ongoing tensions in Japanese society where the ancient cultural traditions, often so alien to us in the West, are in tumultuous conflict with the remorselessly advancing tides of change should provide great material for any kind of writing, and given Japan's position in the vanguard of technological change it seems a little strange that Japan does not feature more prominently in the literature of science fiction. Examine your own lifestyle sometime and see just how many of your 'toys' have a Japanese connection somewhere!

I've extracted a couple of ideas from the text of these nicely crafted tales and then tried to graft these ideas into a simple scene which conveys a more traditional sense of Japan. So we have a slick, shiny lacquered low tabletop and the girl's kimono suggesting the image of Japan we recognize. Look more closely, though, and the patterns on her kimono are not the anticipated butterflies or chrysanthemums but little ringed worlds and rocket ships. The very traditional ivory figurines are not actually resting on the tabletop at all, but hover a few inches above it. Are they holograms? Is the table top a repellor-field of some sort?

In her hands the girl contemplates donning the virtual-reality helmet described in one of the tales. Behind, from another tale is the planet Mars and looming large above that the peculiar potato-shaped little moonlet, Phobos ('Fear') with its immense 10km crater, Stickney. I used NASA Viking Orbiter shots of Phobos to get a degree of accuracy into my depiction of this, the larger of Mars' two little moons.

O PIONEER!
Frederick Pohl
(*Tor Books*)

Apart from producing the cover for *Jem* many years ago, Fred Pohl represents a bit of a gap in the repertoire for me. Some writers' work just doesn't come one's way – probably more by accident than design. And it's a shame, as I think Fred is one of the greats and has been for a very long time, bringing his own witty, satirical edge to the genre. According to the art director for this job I was over-playing the wit element rather too much at the sketch stage and was asked to haul

back a little on the joky resonances. Still, I thoroughly enjoyed this one – and enough humour remains in the image to give me – and I hope others – a bit of a smile.

Fifteen or so years ago I was commissioned by a moderately well-known Hollywood film director to produce a bunch of paintings allied to a dark and fantastical script the title of which I now forget. To cut a long and very slightly acrimonious story short (film work always turns me that little bit greyer!), the project came to naught. I'd taken a whole bunch of reference shots for the male central character which got shoved unused into one of my bottomless

archives of 'may prove useful one day' material – and sure enough, a decade and a half on, one of these shots provided the reference for the character of Evesham Giyt featured on the front cover. The model was hired for an hour or two all those years ago – a professional and no one I knew personally. The likeness on the cover is pretty good – and I'd love to see the guy's double take if he happened to catch sight of the book featuring himself involved in some barmy futuristic altercation with a bunch of big-eared aliens and a coconut shy.

PETER F. HAMILTON

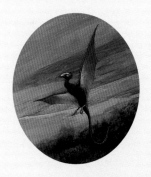

I had to plead with my publisher for five years before I was finally awarded a Jim Burns cover. Worth the wait? Most definitely.

The Night's Dawn trilogy which these pictures illustrate are grand space opera. So, in traditional fashion, we wanted spacecraft hardware on the cover. High-tech machinery against a cosmic background always provides a potent, exciting image. Even today, forty years into the space age, we still stop and stare whenever the television news broadcasts pictures from the NASA Shuttle or Mir. And those vehicles are the steam engine era of space travel. Of course the hardware from 2600 is going to grab people.

There was only one slight snag with this concept. I'd spent a lot of time creating semi-plausible spacecraft, orbital habitats and industrial stations for the books. Now, a lot of artists produce impressive-looking machinery, but somehow it verges between the fantastical and plain fantasy. All very dramatic, but we wanted a scene that was at least relevant to the book, if not taken directly from it. To do that properly, you need Jim.

He looks at what you write, takes that seed of description and visualizes it in a glorious wideband Technicolor. To do this, he concentrates on detail. That's where sloppy writing gets me into real trouble. I got phone calls about starship sensor booms. Which way do they extend? What sort of lens cluster do they use? Combat wasp submunitions. What size? How many? Genetically engineered firedrakes. Wingspan measurement? Plumage coloration? Talon shape?

Friends wonder why my reference notes keep getting larger. It's an essential defence reflex.

Jim, I have to say, is also crafty. Like a conjuring trick that's obvious once it's explained, he uses (I should say, slips in) resonance. Take a look at the smoke trails billowing out from the explosion on the *Reality Dysfunction* picture. The first time I saw it I thought, yes, that's how it would be. That's because those winding plumes are based on the Challenger disaster, an image lodged in everyone's subconscious.

That's what I enjoy most about his work in this particular genre. He's perfected the realism all authors strive for.

Except once. The preliminary sketch for *The Neutronium Alchemist* had the voidhawk docking pedestals at ninety degrees to where I'd put them. The voidhawks would have just dropped off into space. That time, I got to make the phone call.

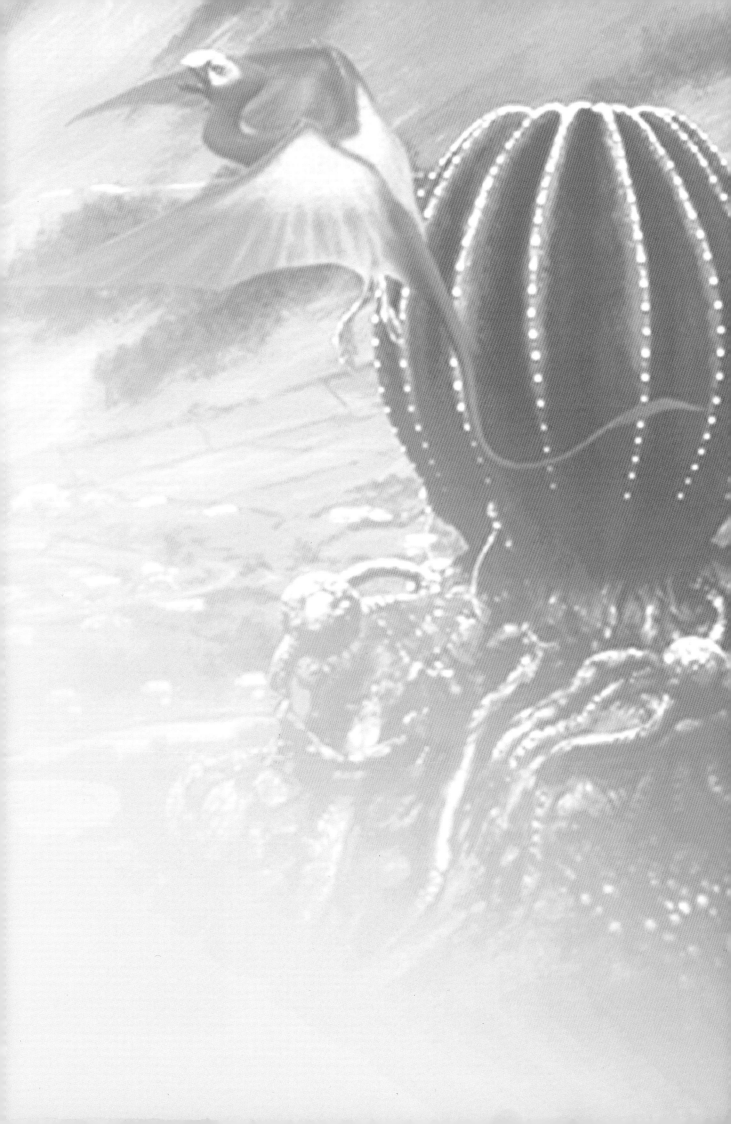

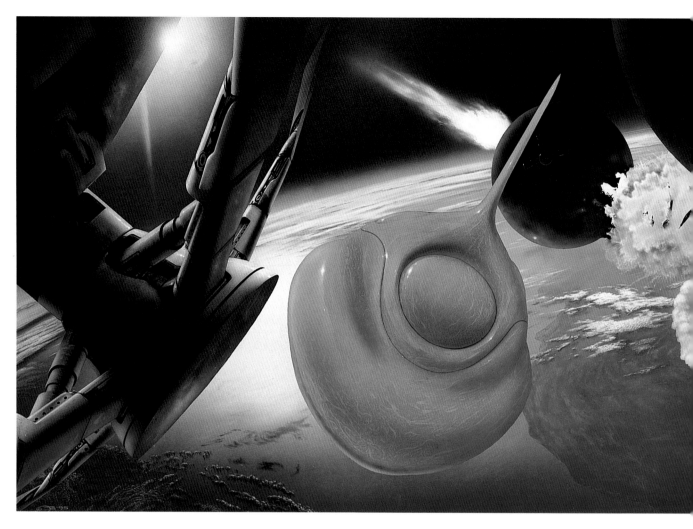

Above:

THE REALITY DYSFUNCTION

(*Pan Macmillan*)

I think I'm correct in asserting that when *The Reality Dysfunction* was published, at 955 pages for the British hardback edition, it was the longest science fiction novel between single covers ever to test the load-bearing capacity of your average bookshop shelving. It held this record for about a year, at which time Pan Books unleashed the second volume of the Night's Dawn trilogy, *The Neutronium Alchemist*, which took the record at one shy of 1,000 pages. Early in 1999 the third volume of this stupendous literary accomplishment will be tossed into the already reeling laps (strange image) of Peter's exponentially growing horde of fans (Peter has threatened to take his own record again) and we will arrive at the conclusion of the one-million-word largest science fiction trilogy ever. There's an epic grandeur to this trilogy, an audacious assault on the high ground of space opera which fills me with total admiration. And it's all so wonderfully readable too!

I know Peter pretty well and I don't think he would take undue offence at my description of him as 'quite quiet'. His books are anything but that. Outrageous,

exuberant, teeming with characters and dense with wonderfully spectacular cosmic incident.

For the first two books in the trilogy, and probably the third as well, it was decided to take a 'hardware-oriented' approach to the cover paintings. I've depicted a somewhat non-specific scene in which one of the sentient Edenist ships, the slick-surfaced Blackhawk on the left, whips aggressively through a formation of the less exotic black, spherical Adamist vessels, whilst a formation of combat wasps rises to meet the challenge from the lower right. Of course, one takes wild liberties with these space-battle scenes; human nature being the way it is, I suppose there is a certain historical inevitability to space dogfights. But you'd never see an orbital battle involving close-proximity fighting like this. The ballistics of the situation and the stand-off ranges of the weaponry employed mean that opposing craft would be unlikely ever to see each other, let alone find themselves manoeuvring about each other at orbital velocities. You'd certainly not get this milling around of hardware in such restricted sectors of low-orbit space. But this is a book jacket. Its remit is the selling of books and neither Newtonian nor Einsteinian physics have any real role to play in the field of bookselling.

Below:
THE NEUTRONIUM ALCHEMIST
(Pan Macmillan)

The second of the monumental Night's Dawn trilogy. An Edenist Voidhawk, the blue, saucer-shaped vessel to the right of the composition, manoeuvres towards its docking ledge on an orbiting bitek semi-sentient space habitat. Adamist globe-ships nestle in the bays built into the spherical docking spindle constructed at one of the habitat's endcaps. This was an opportunity to attempt a portrait of Jupiter and one of its spectacular moons, Io. So it's out with the reference books of all those wonderful *Voyager* shots! Apparently I'm considered, by those who deem it appropriate to apply labels, to be a 'science fiction artist'. This is a quite different subspecies from that rare beast, the 'space artist', best represented in the UK by David A. Hardy and perhaps most famously of all by the great Chesley Bonestell. I've noticed that 'space artists' do on occasion venture off their own turf and into the world of speculative fiction. So it's only fair that I occasionally tackle an accurate planet depiction. I'd love to do a collection of such paintings – though I remember peering reverentially, with the artist Chris Moore, at a large, exquisite lunar panorama by Bonestell in the unmatched Frank Collection just outside Washington DC and I'd have to admit that Bonestell is a pretty hard act to follow.

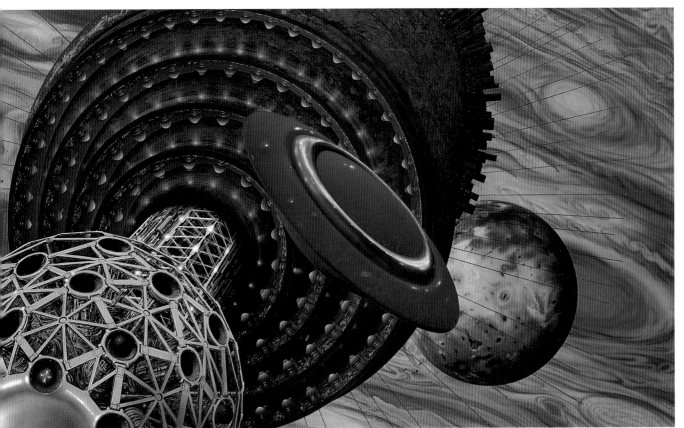

A Second Chance at Eden
(*Pan Macmillan*)

Having proved himself in no uncertain way to be the big novel's Mr Big, Peter Hamilton then demonstrated that the short story form held no fears for him either with the publication of this excellent collection. Set in the same timeline as the Night's Dawn trilogy, *A Second Chance at Eden* further demonstrates the singular imagination of one of contemporary British science fiction's most exciting talents.

Short story collections present the cover artist with a slightly different problem from the straightforward novel form. I've approached collection covers in one of three ways over the years. First of all there is the straightforward ignoring of the book's actual contents. Though to be fair to myself this has

either been because a desired cover motif has been requested by the author (*Songbirds of Pain*) or none of the stories has yet been supplied to the publisher and an 'appropriate' design has been requested, perhaps in the style of earlier books in the series (*Other Edens 3*). A second approach is to ignore all the stories except one and simply paint a narrative episode from that. Possibly a little on the lazy side, but sometimes a singular image can satisfactorily convey the mood or at least give a sense of the collection as a whole (*Artificial Things, Other Edens 1 & 2, Japanese Futures, Kaeti on Tour, The River of Time*). The third approach is the one I adopted with *A Second Chance at Eden* – taking a bunch of elements from several stories and re-combining them into some new image not directly relevant to any one story, but hopefully carrying the 'spirit' of the collection.

The setting is the interior of the bitek habitat from the title story. Perched on the hilltop is the weird living machine from 'Candy Buds', the short story which Peter claims was the inspiration, courtesy of a David Garnett suggestion, for the whole, massive Night's Dawn trilogy. Four Firedrakes from 'The Lives and Loves of Tiarella Rosa' circle around in colourful counterpoint to the mono-chromatically green interior of Eden. In the original sketch the beautiful Hoi Yin from the title story gazed down the length of the habitat from atop the hill next to the candy bud machine, but in the event it was decided she cluttered up the cover design too much and she was unceremoniously dumped.

The idea of the cylindrical space habitat with its seemingly paradoxical but totally feasible internal geometries is one much loved by science fiction writers. I must have attempted half a dozen different ones by now from Rama, the great granddaddy of them all, onwards to this one, my most recent. I still find it extremely difficult to convey an adequate sense of scale to these things. It is very hard indeed to bring conviction to the transitions that take place from the flat landscape nearby into the rising curves of the cylinder – to which one has to add the effects of linear perspective.

All these Peter Hamilton paintings are, by my usual reckoning, huge. At around four feet long they are amongst my biggest. It somehow seems inappropriate to cover these big, big books with paintings that are less than gargantuan!

Jack Williamson is without doubt one of the Grand Old Men of Science Fiction. His writing career goes back to the late 1920s – the very dawn of our beloved genre. And he's still there, still writing! These two titles from his total of over thirty novels are from the early/mid 1980s and, although that makes them relatively modern books, they carry some of that wonderful, 'golden age' nuance that attracted me so much to the literature when I was a young man. Above all else, Jack Williamson tells amazing, readable stories in the classic style with believable characters and no shortage of the gee-whiz factor!

Below:
MANSEED
(*Sphere*)

Manseed is a tale about the human colonizing of alien planets by very unconventional and imaginative means. The consequence of these means are varieties of man/machine hybrid, the fusion of human with robot – that interesting territory of the bio-mechanical interface.

I wanted in this painting to get a feeling of vertigo as we hang high above the canyons below. I hated not being able to incorporate a little of the sky, so the highly reflective dome perched on the canyon edge proved something of a gift and also makes for a nice contrast of texture with the surrounding rocky terrain. The golden figures hanging from their iridescent wings are supposed to have elements of both angels and faery about them.

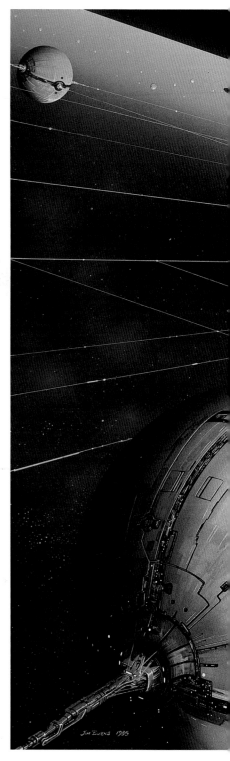

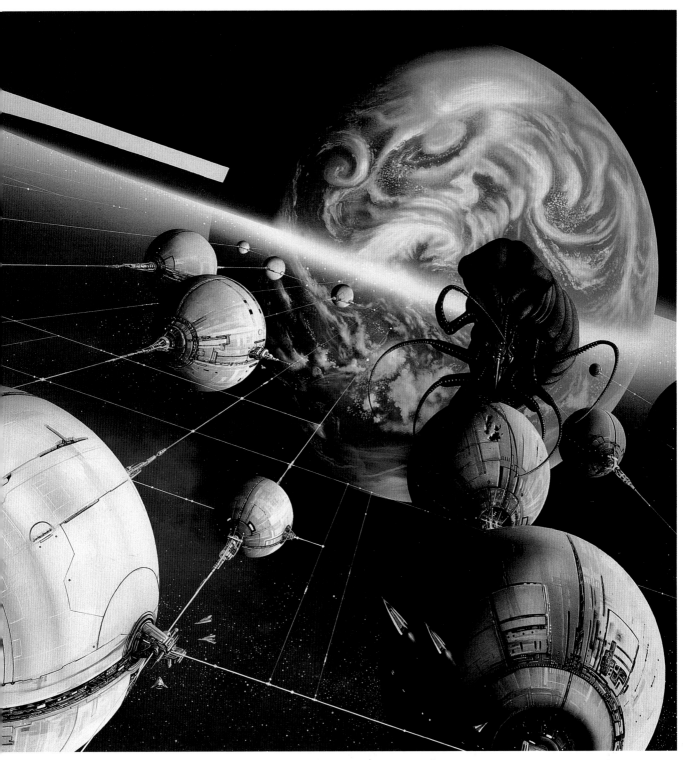

Above:
LIFEBURST
(*Sphere*)

Lifeburst ('the evolutionary leap into space from a planetary birthplace' – as defined in one of the book's chapter headings) is a scary variation on that old berserker-machine theme, but definitely one of the better examples. In the remote past, somewhere out in the vastness of the cosmos, a long-extinct race directed its technological expertize into the development of intelligent cyborg war machines, invulnerable to just about everything, including nuclear blasts. The builders themselves never made it as a space-going civilization: they got eaten by their cyborg creations! (Shades of the 'Terminator' films) Evolving from war machines into something the book calls 'Seekers', but retaining the aggressive instincts programmed into them by their now-extinct creators, the machines themselves make the 'Lifeburst' into space and proceed down the millennia to destroy and consume every trace of life that lies in their path, evolving all the time into ever-scarier and increasingly aggressive beserker machines. Inevitably there is a confrontation with Humanity, the next potential meal on the Seekers' plate. A huge, mean, very hungry and very pregnant queen Seeker arrives in the asteroid belt and gives birth to her ghastly offspring. My painting shows the 'Seeker' infant committing general mayhem in the vast Earth-orbital construct known as the Skyweb. This, as I say is the infant. Its mother is something else again!

Above:

THE FETCH
Robert Holdstock
(*Orbit*)

Rob Holdstock's uniquely idiosyncratic fantasies have always held a huge personal appeal for me – particularly since the publication of *Mythago Wood* which I still rate as one of my absolute favourite genre-related books. I can't read a Holdstock novel with its unsettling visions of a supernaturally altered English landscape without the strains of Arnold Bax or Vaughn Williams manifesting themselves somewhere in my consciousness. Listening to Bax's *Nympholept*, the score of which is headed with the quotation 'Enter these enchanted woods You who dare' and further reference to 'a perilous pagan enchantment haunting the sunlit midsummer forest', one finds a perfect musical analogue to Rob's literary vision. What a creative team they would have made had they not been separated in time by more than half a century!

It wasn't my privilege to illustrate the cover for *Mythago Wood* or its possibly even more accomplished sequel, *Lavondyss* (how I would have enjoyed tackling them!) but my chance to have a crack at a Holdstock cover came along in

1991 with the publication of *The Fetch*, a very different kind of novel, but one still inhabiting that eerie, changed England of Rob's imagination.

So convincing are Rob's descriptive powers that I went around for some time in the mistaken belief that his 'mocking cross', a sort of demonic inversion of the notion of the Crucifix, was a real medieval artefact and not a product of the writer's bizarrely one-off imagination. It was this 'mocking cross' that I decided to feature strongly on the cover with Michael, the little boy possessed with paranormal powers who is the central character of the story, standing in the background against an appropriate piece of Holdstockian woodland. In Rob's text, the 'mocking cross' possesses a sort of twiggy phallus. It was decided at the sketch stage that the wooden woody would be 'inappropriate' and might cause offence (on both good taste and religious scruples fronts) and it should therefore be dropped from the artwork. Reluctantly I lopped off the offending item.

Opposite page:

KAETI ON TOUR
Keith Roberts
(*The Sirius Book Co.*)

A book I've always admired immensely is *Pavane* by Keith Roberts. I think it's regarded by many as being one of the best alternative histories ever written and, in fact, a great book by any measure. I'd never met or spoken to Keith Roberts, so it was a most pleasurable surprise when he telephoned me one day out of the blue in 1992 to sound me out about the possibility of creating a cover for a forthcoming collection of his short stories. These stories were to centre around the adventures of his young heroine, Kaeti – a character previously encountered in an earlier 1986 collection, *Kaeti and Company*. We came to a deal quickly and painlessly over the phone and Keith sent me some text as a jumping-off point – with a view to producing a couple of sketch options. The appealing gamine heroine with her particular brand of cheeky Cockney insouciance was a gift – particularly as it seemed right to feature her very prominently in near-portrait form on the front cover. I needed a model for the character of Kaeti and someone sprang immediately to mind – in part because

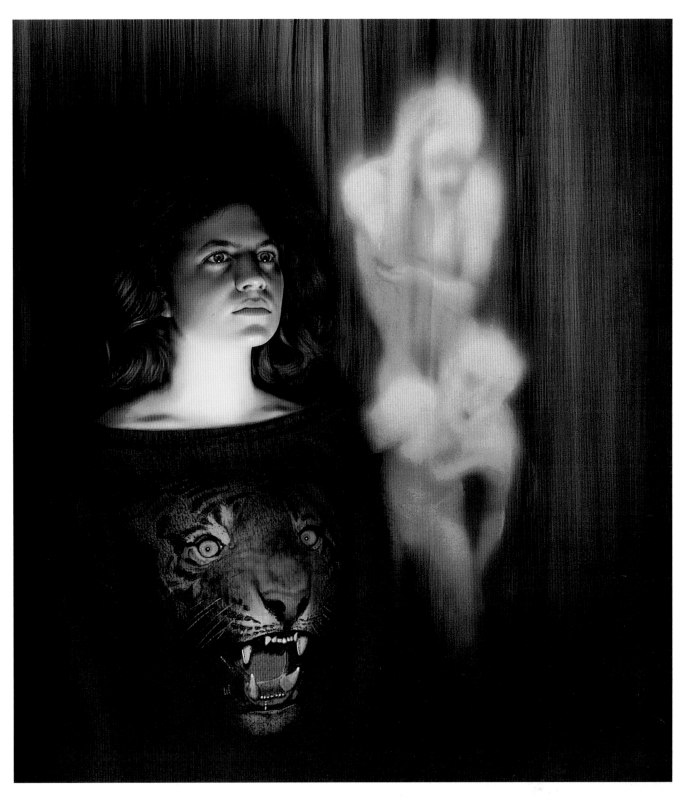

the model's own name – (Katy) triggered an obvious connection, but also because she seemed physically very appropriate for the part. Very pretty in the darkly Celtic way hinted at in correspondence with Keith (he can wax most lyrical on the subject of what he calls 'Primitive Heroines'!).

I was as pleased with my rendering of Kaeti/Katy as I've ever been with a portrait. More importantly, Keith was very happy with it indeed. Katy and myself took the painting down to

Salisbury to deliver it personally. Keith was having a pretty miserable time of it in hospital so we were able to brighten up his time there for a while. To quote a letter he sent me: 'The memory will certainly stay with me; . . . there are or can be few writers whose main character has stepped off the page and kissed them. I'm unsure what conclusion should be drawn from that, except that Kaeti/Katy is even more magic than I allowed for'. A satisfying moment in an illustrator's life.

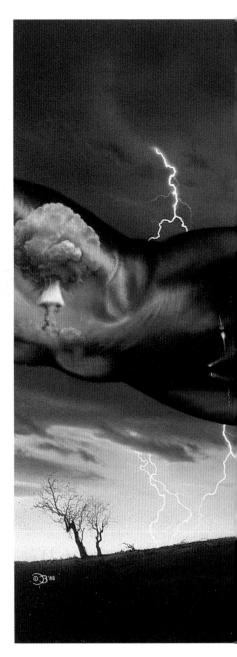

QUICKER THAN THE EYE
Ray Bradbury
(*Earthlight*)

Ray Bradbury is one of the great American storytellers. I've been reading and enjoying his novels and his short stories for decades and so far it's been my great privilege to illustrate the covers to four of his collections. I produced this illustration for the UK paperback edition of *Quicker Than the Eye* in 1997 and, although the collection of twenty-two wondrous tales contained within could have supplied any number of themes and subjects for a cover painting, in the end I decided to create an image of my own which related in no great particular to any of the stories (other than the idea of 'the cupboard under the stairs' from 'The Witch Door', which acted as a sort of framing device). I preferred for once to try to create a notion of the 'Bradbury-esque'.

An image which contained an aura at once faintly surreal, rather nostalgic in some intangible way, a little disturbing whilst retaining just a hint of coziness.

The bright disc of the sun on the front cover mirrors exactly the position of the dark pupil of the eye on the back cover. The wood effect was accomplished very easily and in – for me – a fairly painterly manner with broad, flat brushes. Note the scratches on the opened door – which most people miss! The finish of the wood was achieved by spraying transparent glazes of raw umber and burnt sienna over the yellow base tones. And, as reference material for an accurate sense of the 'woodiness' of the wood, I used the varnished pinewood studio flooring beneath my feet – so for a large portion of the time I spent on this painting I may have been observed head bowed as if in some sort of deep contemplation.

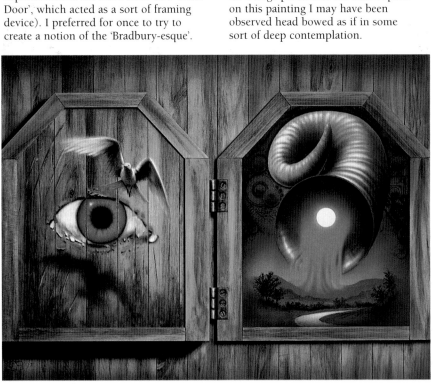

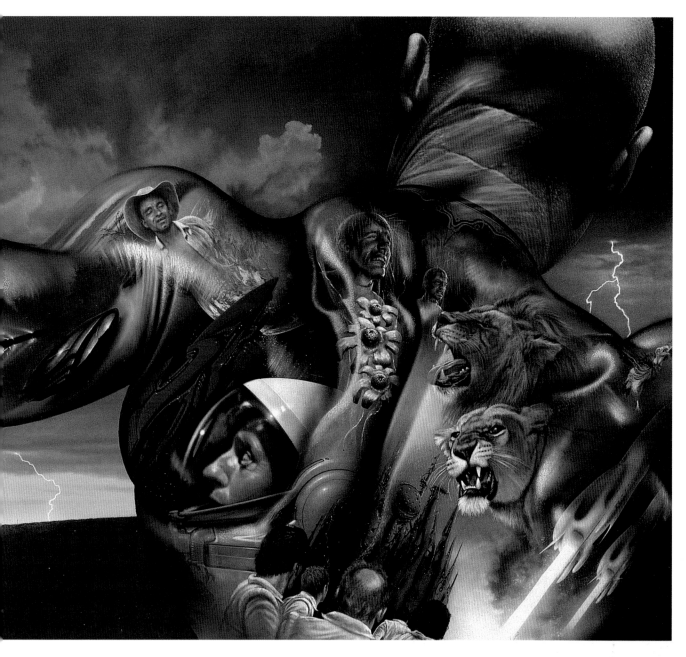

THE ILLUSTRATED MAN
Ray Bradbury
(*Bantam*)

I wonder if there is a single artist out there who wouldn't like to take a crack at Ray Bradbury's classic collection of short stories? The linking tale which provides the framework within which the tales are told presents us with one of fantasy literature's most inspirational characters, at least from the artist's viewpoint. The 'illustrated man' himself is both hypnotically fascinating and sinister at the same time.

Particularly as children, most of us have found ourselves in that strange fugue state (which unfortunately seems to depart with adulthood) whereby the flames in the fire or the complex pattern in a carpet draw one into a strange land somewhere between sleep and waking

and the flames or the patterns become the backdrop against and within which epic fantasies may be acted out. For me this was occasionally very intense – that particular curtain fabric in the living room with the busy and colourful paisley repeats was peopled with all manner of exotic characters and creatures trapped in endlessly repeating loops of movement. The effect was heightened under the influence of those occasional childhood fevers – the up-side of a dose of flu. There was always just a subtle hint of the disturbing about these mild deliriums, and I think it's this common enough manifestation of the growing brains of children that Ray Bradbury has tapped into so masterfully with *The Illustrated Man.*

I never wished to depict the subject as tattooed. It was always essential to suggest movement, colour and the spooky

notion of 'coming alive'. Narrative sequences unfolding before the hypnotized gaze of the boy in the story. Just like in my mum's paisley curtains!

If I'd had the time I would have descended into second and third levels of detail in this painting, whereby, on an ever-smaller scale, the peering eye detects even more mysterious layers of narrative half-hidden beneath the upper layers. As the eye homes inevitably in to the vague detailing of the right shoulder (something I left out of the painting), the trap is sprung and the true nature of the 'illustrated man' is revealed.

95

EXORDIUM
Sherwood Smith & Dave Trowbridge
(*Tor*)

EXORDIUM 1: THE PHOENIX IN FLIGHT (*Opposite page, above*)

EXORDIUM 4: THE RIFTERS' COVENANT (*Below*)

EXORDIUM 5: THE THRONES OF KRONOS (*Opposite page, below*)

The plot of this fast-moving quintet of novels, for which I painted all five covers, follows the fortunes of Brandon nyr-Arkad, the rather ne'er-do-well son (but likeable with it, of course,) of the Panarch Gelasaar, ruler of the Thousand Suns, and his climb from being the family drop-out to the ascent of the Emerald Throne itself. In effect it's a literate sort of *Star Wars* and done with great panache. Space war, weird and wonderful alien life forms, murder and revenge, the falling of empires – in fact, this is great space adventure of a kind you come across, sadly, less and less.I introduced the scary psionic little alien life forms known as the Eya in this first cover and they popped up twice more in my covers for Books 4 and 5. Some writers

provide one with the sketchiest of physical descriptions of their alien creations. The moment an illustrator with a facility to present an artefact or an alien life form in paint with a degree of photo-real conviction tackles a book cover, the things he chooses to paint – if he's done his job well – then tend to become fixed in the mind of much of the readership forever. I remember some years back having a conversation with the writer Sheila Finch at an American World Science Fiction Convention. I'd recently completed the cover for her excellent novel, *Triad* and in the illustration I featured a small gathering of the rather cute, furry, humanoid little aliens she had described in the story. She told me that the way I'd painted them was not at all how she'd envisaged them in her mind's eye but on re-reading her own words she realized that how I'd painted them was 'how they actually were'. Her mind's-eye image of them was consequently altered and whenever she thought of her little furry alien creations now, she pictured them as the beings I had created. Actually, Smith and Trowbridge were pretty precise with their description of the Eya, but I also rather enjoy that

kind of discipline. These scary and rather lethal little beings do almost everything together with a rather unsettling synchrony of movement, hence the weird posturing in the covers for Books 1 and 4. The planetary view from orbit in *The Phoenix in Flight* is adapted from a photograph of the Earth taken from the shuttle Discovery in 1985 and the guy sitting in the control seat, who is supposed to be Brandon himself and is pointing meaningfully at the amber-coloured sphere, is me – from the neck downwards anyway. I screwed a different head on for the painting. As I did with my wife, Sue, whose arm and finger can be seen poking girlishly at some switch or other in front of her.

By Book 5 – *The Thrones of Kronos* – I was really into the swing of the Exordium series. In that picture I was particularly happy with the way the large central spaceship (the 'Telvarna') came out. I really wanted to try and give it a sort of iridescent sheen which meant once again having a little talk with my Badger 150 airbrush. It's a recalcitrant little so-and-so (though not as treacherous as my older, more expensive DeVilbiss which came to a sticky end plunged nozzle first

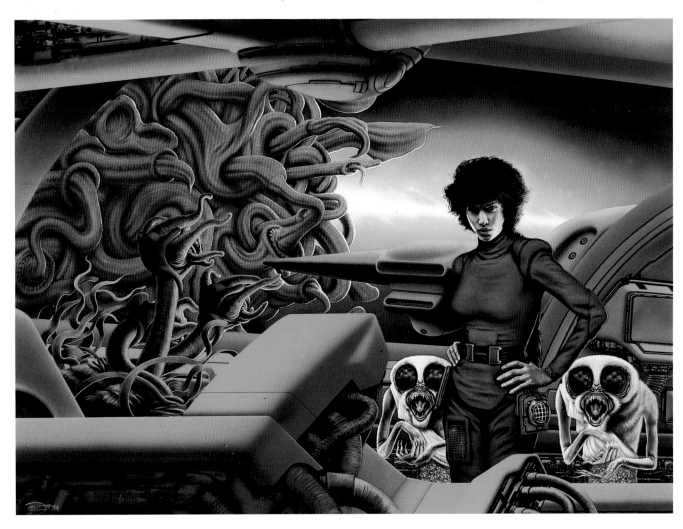

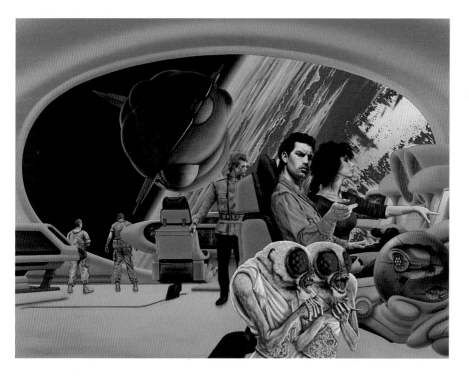

with great and deliberate force into my studio tabletop. It still resides fifteen years on inside a plastic bag reduced to its component elements, a warning to later airbrushes). This time things went swingingly and the ship came out rather nicely. Would-be SF artists should really get to learn the particular strengths of the airbrush and apply it appropriately – and not be afraid to use ordinary brushes. People still refer to me as an 'airbrush artist'. It's just one brush amongst many and I would say I use traditional brushes quite a lot more than my faithful but mischievous old Badger.

I was rather sad to come to the end of painting the Exordium series. It went without a hitch, the client liked the covers and I thoroughly enjoyed painting them. Hopefully they went down well with the authors too, but I don't always get that kind of feedback – except, now I think about it – I did get some enthusiastic murmurings down the phoneline from Sherwood Smith when I bugged her one day for some esoteric detail information.

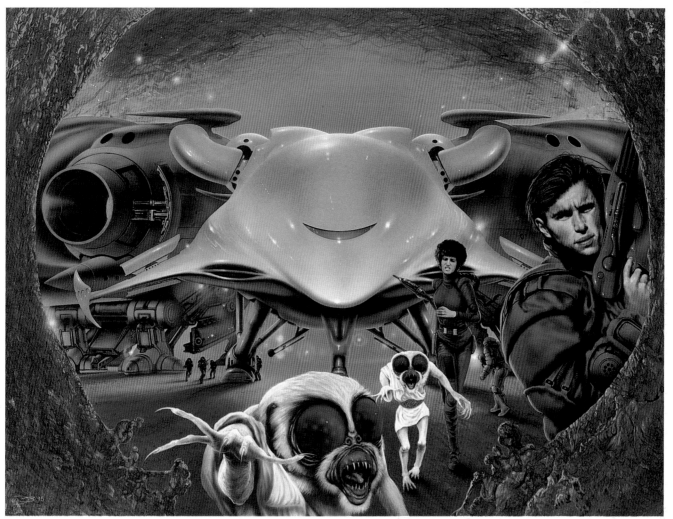

KATE ELLIOTT

When my editor at DAW Books told me that they were going to hire Jim Burns to do the cover for *Jaran*, I wondered how he would adapt his slick futuristic look to a story set on a low-tech world. Without any trouble, as it turned out: lots of grass, the right gear on the horses, that amazing sky, and an architecture that's not quite human and not quite modern. I didn't think he could top that cover. Imagine my surprise when, with my friend Melanie Rawn, I walked into the art show at Worldcon 51 and, across a crowded room, saw the painting for *His Conquering Sword*. Melanie swears that I made a strange noise: a gasp of awe, of surprise, of stunned amazement. Actually, I think I shrieked.

It wasn't just that the composition is both dramatic and assured: the vanguard of a nomadic army sweeps forward toward an unknown destiny while beyond them, and as yet unseen by them, a massive force is about to transform their world. The fire of the spaceship's engines sparks a fire in the grass, the 'fire' that will in time consume their entire culture. In his painting, Jim Burns captured the essence of the book.

That's how good he is.

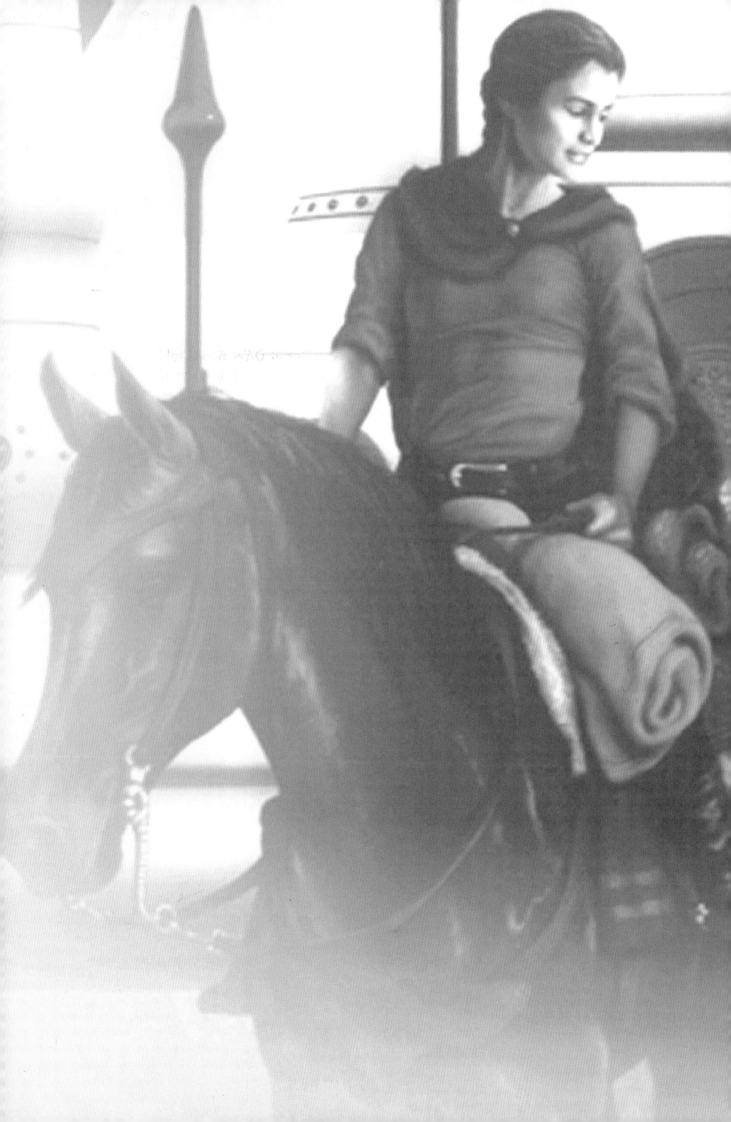

Jaran
(Daw)

Jaran was the first of the series of books by Kate Elliott which told the tale of the Jaran tribes on the planet Rhui. It's a very entertaining and well-paced read and nicely draws together galaxy-wide politics, exciting battles, interesting but convincing aliens and truly sympathetic humans. I've noticed before that women writers within the genre often create more believable, filled-out characters. Perhaps they are less diverted by all the gee-whiz technology male writers get so caught up in! Against the day when I have to defend this outrageous remark at some convention or other I should add that this is, of course, a generalization.

It was an opportunity, as with the three succeeding volumes (*His Conquering Sword*, *An Earthly Crown* and *The Law of Becoming*), to paint horses. Not a thing I felt necessarily drawn to, but which in the event I found extremely enjoyable. They are such beautiful creatures and occasionally (or so I find) not quite believable. I painted the main human character from the series, Tess Soerensen, in the foreground; she is a recent visitor from Earth who has married into the strange Jaran tribal lifestyle and subsequently become embroiled in the turbulently unfolding tale. I was smugly happy with the monochromatically treated background of sky and temple. And, of course, painting just about every blade of grass is bonkers – but fun!

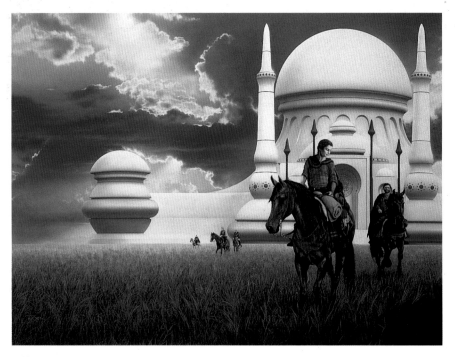

His Conquering Sword
(Daw)

The second of the Jaran series. I enjoy painting that strange conjunction occasionally encountered in science fiction between the quasi-medieval and the overtly high-tech. It can furnish wonderful opportunities for nicely clashing themes, in this case the riders on horseback silhouetted against the mighty blast of a spacecraft launching itself from the plains behind. Possibly a little too closely for comfort for the riders, given the apparent power of those engines – but let's suppose that the

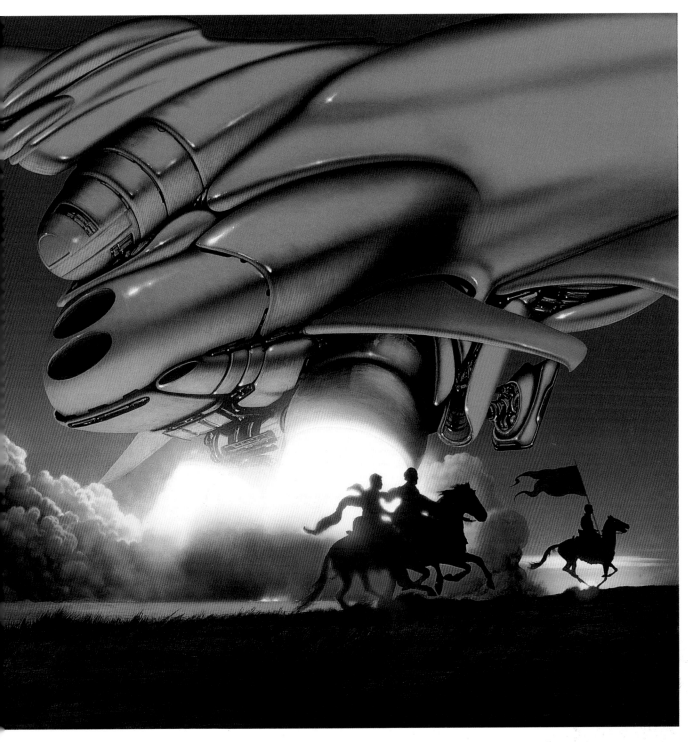

whole scene is viewed through some kind of telephoto lens which has compressed the actual two or three miles to the apparent hundred yards or so. (You can do this sort of thing in paint!) There's a lot of airbrush work in this painting. I used the same blues and oranges as for *Hostile Takeover 1 (Profiteer)* – I find them extremely effective for creating violent drama. The whole ship was painted in Liquitex light blue violet and then the appropriate undersurfaces which would pick up the glare of the engine blast were airbrushed over with cadmium orange. The same cadmium orange was allowed to spill

freely, but with lots of control and high dilution across the lower part of the red oxide sky – again through the airbrush – and more colours, chiefly cadmium reds and scarlets and Turner's yellow were added towards the rocket orifices themselves, where pure titanium white with a hint of primrose yellow provide the actual fiery blasts. This is the sort of thing the airbrush is very useful for. It would have taken me ten times as long using just brushes, and I know that the final thing would not have carried the same degree of conviction. The foreground is completed chiefly in burnt umber, very monochromatically, with the

same burnt umber being used to define the boundary between the blue and the orange on the ship.

A very delightful young lady approached me at the World Science Fiction Convention in San Francisco a few years back and, after introducing herself as one Alis A. Rasmussen, proceeded to wax enthusiastic about this painting. It transpired that Alis Rasmussen is also Kate Elliott, and after some fairly amiable haggling Kate/Alis took *His Conquering Sword* off to hang on her wall. As much as I would have liked to have hung onto this painting, I acknowledge that it could not have gone to a better home.

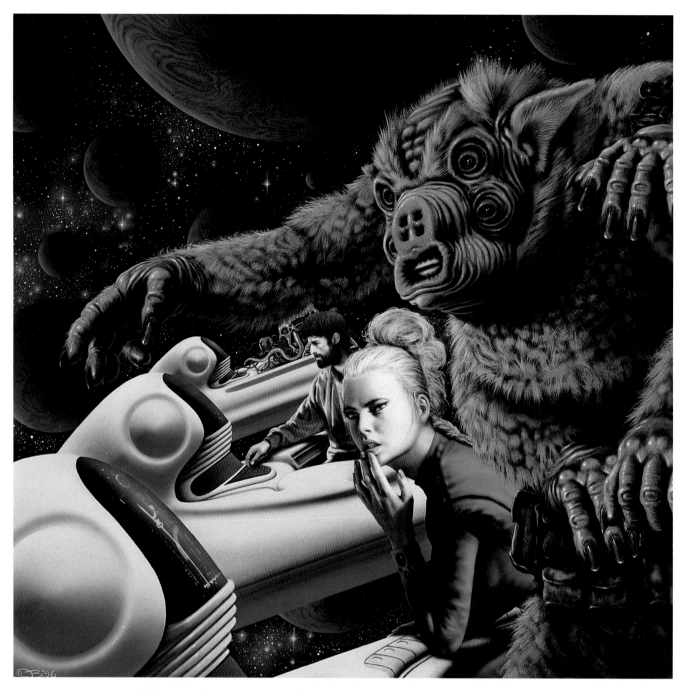

Above:
STARPLEX
Robert J. Sawyer
(*Analog*)

Robert J. Sawyer describes Jag Kandaro em-Pelsh the Waldahud as 'a shaggy pig-like creature with six limbs'. His 'untranslated voice sounded like a dog barking, with occasional hisses and snarls thrown in for good measure'. He is 'well insulated with fat' and there are descriptive words like 'obnoxious, argumentative and pushy'. One notes too from the text that the creatures are arrogant, bullying, and very ugly (to human eyes), with their squat bow legs, stacked vertical pairs of eyes and four nostrils. I do like painting those species of aliens which retain a reasonably close

proximity to the human form. They are exercises in subtlety and quiet 'otherness'. But just occasionally it's very liberating to get to grips with an outrageous being like Jag who fulfils all our repelled preconceptions of the revolting alien. This one even has the nerve to insist that humans shower twice a day, so revolting is our smell to him! A truly unpleasant creation but such fun to paint!

Opposite page:
SPACE OPERA
Various
(*Daw*)

A nicely punning title to a musically themed collection. My levitating alien virtuoso was, at sketch stage, much more elfin/humanoid, but it was felt that the design didn't scream 'science fiction' loudly enough and I was asked to imbue the creature with more BEM attributes. The art director was quite right and the image was much improved as a consequence. She kept her furry breasts, though. I prefer to convey strange other-worldliness with quietly offbeat images rather than the usual exploding starship cliches. Having said that, one doesn't like to go too long without the occasional, very necessary fix of an exploding starship.

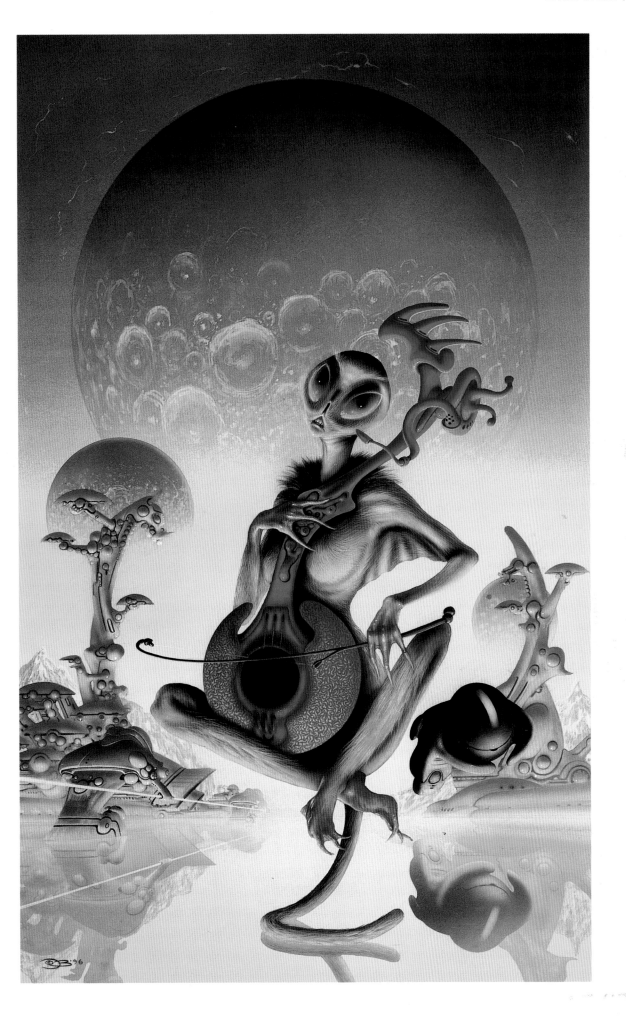

THE MUTANT SEASON
Karen Haber & Robert Silverberg
(*Bantam*)

This was the first volume of a quartet of novels by Karen Haber for which I was commissioned to do the covers. It investigates the interesting notion of a race of more highly evolved Humans secretly living amongst us and upon this premise builds a story which cleverly addresses the nature of prejudice and bigotry. The fate of the Earth itself and the future of Humanity is the prize, and the problems and implications of sudden, radical evolutionary change is something which, in the light of real advancement in the biological and genetic sciences, we'd be well advised to consider very closely indeed. This is science fiction as the 'literature of warning' which I always regarded as one of the better definitions of the genre. The young woman in the illustration is a mutant, but the physical manifestations are slight indeed. How much more pleasing it is to embrace subtlety in the execution of such pieces rather than go sailing off down the more obvious and outrageous routes!

THE MAN WHO MELTED

Jack Dann
(*Bantam*)

I do prefer a free brief in which I'm allowed to read the manuscript and come up with the ideas. It's not always possible for one reason or another and occasionally a previously very flexible art director will turn (usually temporarily) all specific and demanding. This was one such job, its details defined very precisely for me

in the brief sheet. Fortunately the scene chosen could easily have been the one I would have homed in on anyway.

This is a terrifying and highly literate read about mass psychosis. A planet-wide telepathic wave sweeps the Earth, driving those under its influence towards a desire for self-annihilation. It is a very powerful and compelling book with sympathetic and convincing characters – not always the strong point of much science fiction.

The green female face emerging from the crude statue head is supposed to be a holographic projection. Believe me, it is not easy trying to convince in paint that what you're looking at is the three-dimensional image produced by the illumination of the pattern created by the interference between a coherent lightbeam and light diffracted from the same beam by an object. You can only do so much with tubes of acrylics!

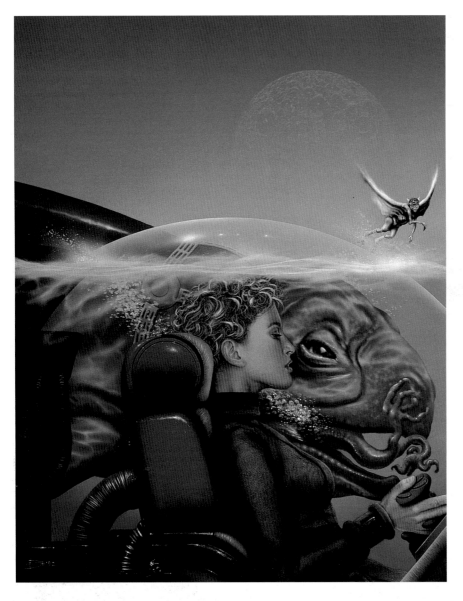

Opposite page:
DORS VENABILI
Isaac Asimov
(*Asimov's Science Fiction*)

I believe this was the last piece of science fiction Isaac Asimov wrote before his death. As such it was a privilege to be invited to illustrate it for the April 1993 cover of the magazine that famously bore his name. If fallible memory serves me correctly, it's the only cover I've painted for an Asimov story, which certainly seems a sad omission. The novella *Dors Venabili* belongs in the universe of his famous Foundation books, and it was thought to be a good idea – and one which I would certainly endorse – to feature Isaac Asimov himself in the painting, enacting the part of his legendary hero, Hari Seldon, standing behind his robot wife, after whom the story is named. I was supplied with good black and white reference photographs of Isaac Asimov and the portrait is a literal transposition of one of those photos into paint with a little imagination applied to his clothing. A great face to paint with those strong features loaded with wisdom and character and, of course, the famous mutton chops!

Above:
POLES APART
Gerald Nordley
(*Analog Science Fiction*)

Poles Apart was the very first job I was commissioned to paint for *Analog*, the famous US specialist science fiction magazine. I've completed quite a few more since and also for Analog's sister magazine, *Asimov's Science Fiction,* and they always seem to find me an interesting or offbeat tale to paint like this little gem by Gerald Nordley (I also produced the cover for a later edition of *Analog* which contained a sequel to this story called *Final Review*). It's an exciting but sensitively handled tale of the relationship between three very different sentient species who inhabit the planet of the story. One of these species is Humanity, represented in the painting by the young woman who is the appealing central character of the story.

I met Gerald at a convention shortly after the magazine came out. He was very complimentary about the cover which I had up in the art show at the time. It went into the art auction and achieved quite a good price, but my pleasure was a little tempered by the fact that, unknown to me at the time, Gerald had had his eye on it, but didn't make it to the auction on time. He was a little disappointed, but made sure he was first in line when the cover for *Final Review* became available!

COLIN GREENLAND

As an SF writer, I've had some pleasant moments. One was when they handed me the Arthur C. Clarke Award for *Take Back Plenty*. Another was when the phone rang, and it was Jim Burns saying, 'Colin? Apparently I'm doing your next cover.'

Most artists won't even read the book, let alone talk to the author. No time, no time.

Jim insists on reading the book. Then he tells you how much he enjoyed it, and asks you what you'd like on the front. Oh, and of course the other thing about Jim is, that thing about being the best SF artist on the planet.

As you can see.

Here he's got Tabitha at her peak, being queen of the icky world that she's made off with. He's got her snarling bodyguard, and one of her scariest associates, glowing red eyes and all. (I love those eyes.)

While I was writing *Mother of Plenty*, the final Tabitha book, I had a copy of this painting over my desk. When the characters were speaking, I could look up and see them.

Not many authors get a visual aid like that.

Mother of Plenty:
So I said: 'Give him a supermarket trolley. Oh, go on, Jim, it'll be great.' Thinking: He never will.

And Jim chuckled, and made a note of it, along with my 9704 other brilliant ideas. He's a wonderfully patient chap, Jim, and very polite. He never actually says: 'Look, Greenland, who's painting this picture, me or you?'

He must be terribly tempted, though, sometimes.

Yet when he sent me the picture, there was O'Shaughnessy the Altecean, complete with trolley.

So then I thought: HarperCollins will never accept it.

But they did.

And then I thought: Oh, it's right on the edge, it'll get trimmed off. But it didn't.

I'm more pleased about that than I can say. The great thing about science fiction, and about space opera above all, is that there's room in it for everything. Everything we are, and everything else as well.

That, if you like, is the Plenty Principle.

SEASONS OF PLENTY
(*HarperCollins*)

I read the first volume of Colin
Greenland's Plenty trilogy (*Take Back
Plenty*) on a beach in Crete in order to
bring me up to running speed for the
second volume for which I'd been asked
to provide the cover art. (A different
artist had completed the first.) Usually,
I spend my holiday time catching up on
recommended mainstream titles, giving
myself a break from the total year-long
immersion in SF, which may sound a
little strange to some of those fans one
occasionally meets at conventions for
whom there is no life beyond science
fiction. I have to say that lounging on the
beach at idyllic Loutro with the
mountains behind and the 'wine dark sea'
in front, a limitless supply of ice-cold
Retsina and the smell of lamb barbecuing
outside the little taverna two minutes'
walk away is a fine enough way to
spend the time anyway. A truly great yarn
was needed to make the holiday even
more perfect. *Take Back Plenty* was just
that, and with the Plenty trilogy, I think
it's fair to say that Colin established
himself as the writer who, more perfectly
that anyone else, understands the term
'space opera'.

What a wonderful, epic sprawl it is.
In the end how could I not have Tabitha
Jute (and who has not fallen head-over-
heels for our warts-and-all heroine?) as
the main front-cover element? I bugged
Colin over the phone incessantly in my
attempts to fine-tune certain details and
I'm sure some of my questions must have
sounded pretty bizarre. Xtasca, the
strange little cherubic Seraphim space
being (with overtones of the Mighty
Mekon!), provided us with a merry
conundrum in respect of the provenance
of his/her/its navel. The Thrant body-
guard's actual physical size was a source
of previously unconsidered speculation.
Still, I think Colin has a penchant for the
bizarre and when I said to him, 'Send me
your clothes' (having had a fair spot of
bother tracking down a suitable leather
coat for Tabitha, as described in some
detail in the story), his own leather coat
– the one you've all seen him wearing at
conventions – promptly turned up in the
post. My two eldest daughters took turns
wearing it, modelling the reference
photographs, 'Hey, dad – this coat's real
cool – can we keep it?'

I don't think I've ever enjoyed the
process of science fiction illustration
more than during the execution of
this piece.

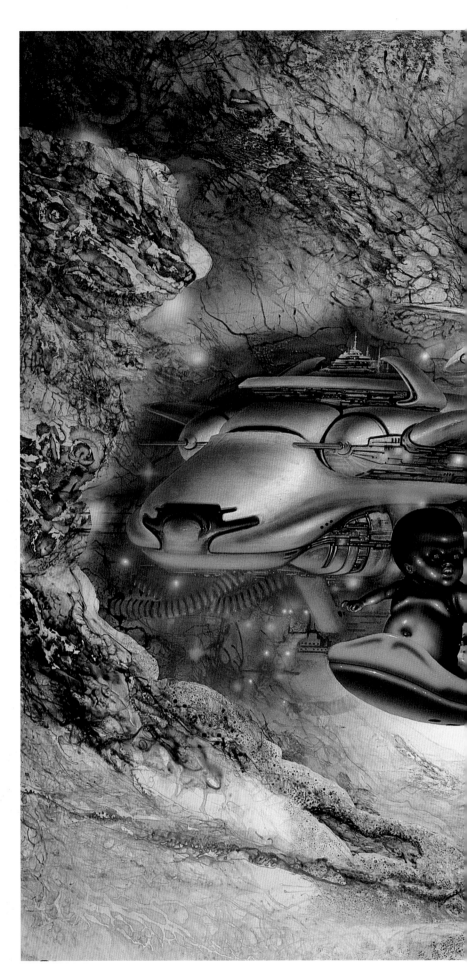

MOTHER OF PLENTY
(*HarperCollins*)

The triumphant end to the Plenty trilogy. Tabitha Jute muses upon her situation, having crash-landed on a bizarre planet in the Capellans' home system. The setting is actually something of a composite location. The artwork was deliberately designed to work as the covers for two different books – primarily the above title, but also for Colin's short-story collection, *The Plenty Principle*. The scene combines the landscapes of Capella3 and Umbriel, a moon of Uranus from the short story 'The Well Wishers', which manages to encapsulate very nicely that unique Colin Greenland trick of 'Lewis Carroll and Salvador Dali meet on the set of Star Wars'. I didn't have a manuscript for *The Plenty Principle* so, after (another!) lengthy phone conversation pumping Colin for information, he came up with a list of about seventy-five possible visual

'devices' – resulting eventually in the silver bird stuck tail-first in one of the pools. The spindly tree-like forms are the desiccated corpses of Frasque, the rather hideous alien species Colin describes with such repellent but eloquent relish. The womble-like Altecean to the right of the composition, a taciturn but acquisitive alien species, is seen pushing along a supermarket trolley full of various bits and pieces found littered about on the surface of the Capellan planet – so, we have a Hugo Award (they do go missing from time to time – ask John Clute!), a copy of *Seasons of Plenty*, my daughter's saxophone, a rolled-up newspaper, a ball, a computer (because I'd just bought one) and, underneath, a brown betty teapot – simply because a brown betty teapot being rolled across the surface of a moon of Uranus in a supermarket trolley by a scruffy, unkempt alien with huge chicken-feet and a rucksack on its back is just so – Colin Greenland!